HAUNTS OF VIRGINIA'S BLUE RIDGE HIGHLANDS

HAUNTS OF VIRGINIA'S BLUE RIDGE HIGHLANDS

JOE TENNIS

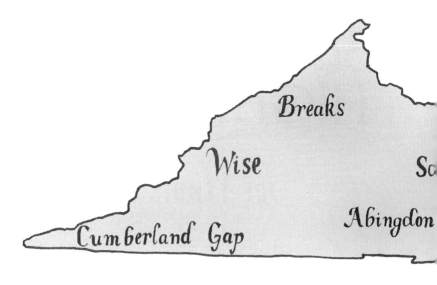

Virginia's Blue Ridge Highlands straddles the Blue Ridge Parkway and reaches southeast to Martinsville. The region also stretches across the entire length of the Crooked Road: Virginia's Heritage Music Trail in southwestern Virginia. *Map by Raven Marin.*

Published by Haunted America
A Division of The History Press
Charleston, SC 29403
www.historypress.net

Cover image: Monterey is a landmark standing at the edge of the Roanoke College campus in Salem, Virginia. *Courtesy of the author.*

First published 2010
Second printing 2010

Manufactured in the United States

ISBN 978.1.59629.988.7

Library of Congress Cataloging-in-Publication Data
Tennis, Joe.
Haunts of Virginia's Blue Ridge highlands / Joe Tennis.
p. cm.
Includes bibliographical references (p.).
ISBN 978-1-59629-988-7
1. Ghosts--Virginia, Southwest. 2. Ghosts--Blue Ridge Mountains Region. I.
Title.
BF1472.U6T46 2010
133.109755--dc22
2010027740

Notice: The information in this book is true and complete to the best of our knowledge. It is offered without guarantee on the part of the author or The History Press. The author and The History Press disclaim all liability in connection with the use of this book.

For Maggie, Sam, Jessie and Jake

CONTENTS

CONTENTS

CONTENTS

Roanoke Region

Afterword

ACKNOWLEDGEMENTS

For help in completing this book, foremost thanks goes to the staff of The History Press, especially Hannah Cassilly and Amber Allen.

Additional thanks goes to fellow authors, writers, editors and historians, most notably V.N. "Bud" Phillips, Cara Ellen Modisett, Tim Cable, David McGee, Bill McKee, George Stone, Jan Patrick, Jennifer Estep, Carol Jackson, Linda Hoagland, Donnamarie Emmert, Richard Ernsberger Jr., Laura All, Carolyn Sakowski, Sherry Lewis and Daniel Lewis.

Several people also provided help with this project, including Carol Borneman, Lucas Wilder, John Gillenwater, Ethan Sivley, Martha Wiley, Robin Marcum, Tammy Scott, Margaret Scott, Gary Carroll, Andrew Pauly, Roddy Moore, Rhonda Robertson, Fletcher Dean, Bill and Nancy Jones, Kathy Still, Jewell Worley, Ben Mays, Charles Lewis, Charlie Engle, Ann Duesing, Sandi Roscoe, Nancy Slemp Salyer, Lynda Hubbard, Wayne Leftwich, Jerry Wolfe, Matt and Jenny O'Quinn, James L. Childress, Terry Owens, Carl Mullins, Carl P. Mullins, Charlotte Whitted, Gaynelle Thompson, Ginger Branton, Louise Leslie, Raleigh Clark, Maddie Gordon, Ronnie and Helen Gordon, Shelia Salyer, Bill Hileman, David and Patsy Phillips, Bob and Suzy Harrison, Rex and Lisa McCarty, Charles and Linda Burkett and James McCrary.

Acknowledgements

More help came from Shirley Adair, Lisa Meadows, Kimberly Leonard, Brad McCroskey, Ginger Miller, Carl Moore, Mary Beth Rainero, David Shumaker, Tim Buchanan, Darlene Cole, Peter Yonka, Richard Rose, Donna Price, Melissa Watson, Mike Shaffer, Christine Webb, Dirk Moore, Lorraine Abraham, David Baber, Robert Vejnar, Jerry Catron, Eleanor Walker Jones, Jim Glanville, Charlie Bill Totten, John Morgan, Bob Maule, Mike Taylor, Fred DeBusk, Gary and Linda Sutherland, Harry and Melinda Haynes, Renel Gambrill, Douglas Ogle, Brenda King, JoAnn Scott, Penny Plummer, Denise Smith, Josiah Smith, Ron Kime, Connie Janowski, Jeanne Davis, Cathy Reynolds, Mary Lin Brewer, J.C. Weaver, Barry O'Dell, Nick Ferra, Donna Wilson, Tami Quinn, Sue Story, Kim Hill, Taphne Taylor, Donny Collins, Charlie Alley, Shana Enter, Brandon McCann, Craig Distl, Jonathan Romeo, Peter Givens, John Nunn, Bob and Theresa Lazo, Love Cox, Allen Worrell and Wayne Worrell.

I extend more thanks to Steve and Kim Rhodes, Dave Wood, Claiborne Woodall, "Buffalo" Jack Price, Shai Cullop, Ricky Cox, Cindy Porterfield, Michael Marcenelle, Brad Bentley, Sue Robinette, Susan Mattingly, Flavio Carvalho, Rance Edwards, Robert Krickus, Bonnie Roberts Erickson, Teresa O'Bannon, Catherine Osborne, Gene Hyde, David Horton, Ann Bailey, Sara Zimmerman, Ed Moorer, Buzz Scanland, Marsha Stevers, Michael Porterfield, Shelvy Worley, Anita Hines, Pat Lane, Jim Myers, Eric Wolf, Diane Givens, Frank and Gerlene Sizer, Philip Atkins, Teresa Gereaux, Tom Carter, Catherine Fox, Michael Quonce, Anne West, Paige Ware, Tim Miller, Paul and Terry Tucker, Edwin McCoy, Annette Allen, Taffney Mays, Libby Bondurant, Linda Stanley and the Franklin County Historical Society, Tom Perry, Dora Jane Barwick, Felecia Shelor, Dr. Casey Davis, Debbie Hall, Virginia King, Paul and Pat Ross, Lisa Martin, John Reynolds, Beth Almond Ford, Sharon Kroeller, Raven Marin, Daniel Rodgers, Mike West, Steve Galyean, Tony and Tammy Balthis and the staff of the Washington County Public Library in Abingdon.

Finally, I thank family members, most especially James and Melissa Caudill; John Wolfe; Dr. Walter Wolfe; Jo Boswell; Rob and Michelle Tennis; my parents, Richard and Jeanette Tennis; my wife, Mary; my daughter, Abigail; and my son, John Patrick.

INTRODUCTION

Virginia's Blue Ridge Highlands holds a wonder of waterfalls, rocky canyons and mile-high mountains. Scenic villages called Woolwine and Meadows of Dan share the skyline of the Blue Ridge. Yet also lacing this landscape is a labyrinth of legends—in caves, colleges and historic homes.

Neighbors tell of haunted houses from Hiltons to Hillsville, and stories have circulated for years at the Major Graham Mansion near Wytheville and Avenel in Bedford. In Grayson County's Grant community, homeowner Kim Hill has reported unexplained sounds at the allegedly haunted Willis House—including what appears to be a bowling ball rolling across the wooden floor of the second story and slamming a set of pins, always scoring a strike. An explanation remains unclear, but the sound could be related to a former resident who lost her life in a traffic accident.

Schools across this region have collected ghost tales at the college campuses of Radford, Salem, Emory and Wise. The old Christiansburg Middle School bears the century-old legend of the Black Sisters while, in Abingdon, multiple stories told of the Civil War relate to the old Martha Washington College for Women, now known as the Martha Washington Inn.

Some ghostly sightings of this mountainous region, however, have no tale attached—such as the wispy Lady in White on the sixth floor of the Hotel Roanoke or the mysterious phantom jogger breezing

past the Virginia Tech Duck Pond. Some ghosts, too, are phonies, like the Coon Ridge Ghost of Carroll County—a haint owed to Larry Cochran, who paraded down a road around 1960 wearing a sheet and carrying Joe David Horton on his shoulders. A more celebrated spirit—Tazewell's Woman In Black—once haunted Pine Street in the early 1900s, making businesses close early and residents stay put. Many decades later, the truth was finally revealed: John W. Laird played this part, dressed in a long black skirt with help from businessman H.W. Probst.

At least one ghost in Washington County even made headlines: the *Bristol Herald Courier* reported on April 15, 1926, that a "Ghost Appears Every Sunday in House" at Green Spring near Abingdon. This ghost made itself known by "a prolonged and unearthly whistle and the blowing of a horn. Then he proceeds to give a knocking performance." About thirty people heard this one Sunday evening and offered various opinions. Some surmised that this was "the shade of a nearby farmer, who departed this life more than a year ago, who is trying to tell the location of his buried treasure."

Herein lay the Haunts of Virginia's Blue Ridge Highlands. This book bridges the Blue Ridge Parkway and follows the entire length of the Crooked Road: Virginia's Heritage Music Trail—from Rocky Mount to Breaks Interstate Park. It explores a couple dozen counties, with tales of towns called Fincastle and Saltville tucked away in Virginia's scenic southwestern corner. Each chapter is based on a blend of folk legends, longtime traditions, historical research and firsthand accounts.

HEART OF APPALACHIA

*Cumberland Gap—Sugar Run—Powell River—Josephine—
Wise—Breaks—Cedar Bluff—St. Paul*

THE LAST REBEL

Cudjo's Cave—Cumberland Gap, Lee County

Deep below the earth, Confederate warriors scratched their names in a dark cavern at the Cumberland Gap, captured by what one artilleryman called "the most gorgeous and weird scenery imaginable." As many as sixty men left signatures—in candle smoke—on the cavern's walls and ceiling. But one, it's believed, might have also left behind his spirit.

Virginia makes its last reach to the west at the Cumberland Gap—a natural notch on Cumberland Mountain where it was once thought that America's greatest Civil War battle would be fought. Confederate general Felix Zollicoffer was sent to fortify the gap as early as 1861. Later, as the war lingered, some surmised that any invasion—by the North or South—would come through this cut in Lee County at the border of both Tennessee and Kentucky.

For forty-four months, the Union and the Confederacy played a game of wait and see. Soldiers—wearing both blue and gray—stripped beautiful Cumberland Mountain of its coat of many colors. They knocked down forests so that limbs and logs would not block gunfire. But, what these soldiers may have really fought was boredom. Four times the Cumberland Gap changed hands. All the

while, soldiers probably panicked because poor roads made it hard to re-supply the barren site with food.

For storage, troops turned to the crevices of the cavern—the Soldiers Cave—on the Virginia side of Cumberland Gap. Hundreds wandered into this world of wonder, fascinated by the formations of stalagmites and stalactites. Colonel James E. Rains of the 11th Tennessee Infantry bragged of the cave in an 1862 letter to his wife, saying, "There are towers & statues, pools of clear water, beautiful arches, & splendid chambers…It is perhaps the most beautiful cave in the world."

Long after the war was over, a section of this subterranean system became King Solomon's Cave when it was developed for tours in the 1890s. Then, sometime after 1934, a tunnel was dug to link the Soldiers Cave to King Solomon's Cave. After that, the entire cave system won a new moniker—Cudjo's Cave, for a novel of the same name by J.T. Trowbridge, released during the war in 1864. In that

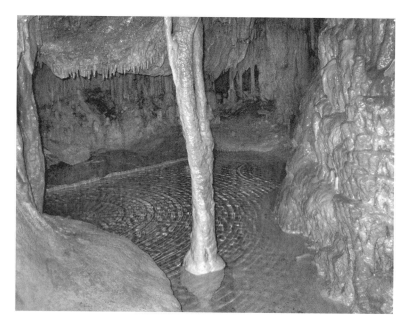

The shallow pool of Cleopatra's Bathtub is one of the many unique formations in Cudjo's Cave—now called Gap Cave—at the Cumberland Gap National Historical Park of Lee County. *Courtesy of the author.*

book, Cudjo and the other characters explore a large cave in the Cumberland Mountains and are amazed, as Trowbridge writes, by "the vastness of the cave, the darkness, the mystery, the inky and solemn stream pursuing its noiseless course."

Darkness and mystery remain part of the modern tours of the real-life Cudjo's Cave—unlike earlier years, when the roadside attraction was illuminated with dozens of electrical lights. For decades, commercial tour brochures in the mid-1900s advertised the unparalleled beauty of this place, where "calcite crystals scintillate like millions of glittering diamonds."

Rangers of the Cumberland Gap National Historical Park now call this Gap Cave and lead tours with just flashlights and helmet bulbs to light the way.

It is in this darkness, some rangers say, that a leftover looms: the bearded face of a Confederate officer, hovering back and forth between the two main channels of the cavern. This ghostly man appeared to join a cave tour during September 2009. Inside the cavern's Music Room, the spirit briefly showed his countenance to John Gillenwater, a seventeen-year-old ranger, who recalled, "I never thought there was a ghost—until I saw that."

About a week later, John Gillenwater and another young ranger, Lucas Wilder, showed off Cleopatra's Bathtub, a shallow pool, while leading a middle-aged couple on a typical tour. Lucas took the lead but was soon taken aback when he noticed what appeared to be disembodied legs, running in the distance.

Slightly shaken, Lucas marched on to the Music Room. He sang his usual mournful version of *Long Black Veil*, demonstrating the dynamic echo of the cavern. Then he climbed the forty-four steps of the Ultimate Thighmaster, a steep set of often-slick stairs. Lucas held his head down to maintain his balance.

Looking up, he froze in fear.

"There was a man sitting at the top of the steps. He was looking straight at me," Lucas said. "I was scared to death when I saw it. I was just ready just to fall off."

This man was stout. He wore a Confederate officer's jacket with two button rows on the front, a colored strip down the side of his pants and boots that stretched about halfway up his calves. He had no

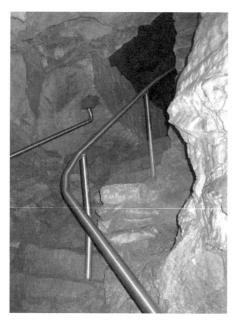

A stairwell connects King Solomon's Cave to the Soldiers Cave at the Cumberland Gap National Historical Park. These sections were connected sometime after 1934 and became known as Cudjo's Cave, later renamed Gap Cave. *Courtesy of the author.*

hat, Lucas said, but he did wear a beard—unkempt, gray and stretching to the center of his chest.

Lucas saw the man for about four seconds. "He didn't look dead," Lucas said. "His eyes were hollow. There was no eyeball that I saw. It was more like just a hollow eye."

Comparing notes, Lucas and John later realized they must have—separately—seen the same thing: a ghostly Confederate officer with a scraggly beard. "He was a big guy," John Gillenwater recalled. "I didn't get the feeling that he was there to hurt anybody."

Possibly this Confederate officer had signed the wall of the cave with graffiti, but his name was erased when the Soldiers Cave was connected to King Solomon's Cave in the 1930s. And, perhaps now, the rangers say, that's why the last rebel roams, back and forth, letting his weathered face be known inside that deep, dark cave at the Cumberland Gap.

ECHOES OF WAR

Sugar Run, Lee County

At thirteen, the coal miner's daughter raced, tearing off with her aunt and a family friend—breath-heavy, her long hair flapping in the breeze. This girl—nicknamed Sis—followed an old, familiar

path across a ridge between Fleenortown and Sugar Run. But as the aunt and the friend climbed over a fence, Sis went under—just to be different.

That's when she heard it: the ground shaking, men screaming, horses running and great gobs of gunfire. It sounded just like a battle was going on!

This Lee County area had been spotted by Civil War skirmishes. Fights erupted over which side should control the Cumberland Gap, and that sparked a battle for nearby Jonesville in 1864. A few months earlier, the Lee County Courthouse at Jonesville went up in flames, having been torched by Union soldiers in 1863, hardly more than a few hills from this ridge.

On this spring day, in 1953, Sis heard what appeared to be the echoes of war. It lasted twenty seconds—or, just enough time for the girl to go under the fence and get off the ground.

Standing up, all was silent. The shaken girl ran ahead to her aunt and friend.

"Did you hear that?" Sis asked.

"Hear what?"

"A battle," Sis said. "There were cannons. It sounded like wagons were rolling so close to me, I thought I was going to be run over."

"No," one said, laughing. "We didn't hear a thing."

Again, on another day, this girl would cross the ridge and follow that old, familiar path. But never again would she climb under that fence and put her ear to the ground.

STANDING ON THE ROCK

Powell River, Wise County

One old-timer simply called Sally "fat—in a family way." Still, others were more polite, saying Sally was heartbroken: her beau had gone away and now so would she.

Sally had once lived in the wilds of Wise County with her father, where the Roaring Fork meets Canepatch Creek. But she had moved on, around 1900, and that's when she had toyed in the troubles of love.

After a while, Sally grew despondent—and so sad that one night she left her sister's house in her nightgown and ran to the Powell River.

Carefully, Sally's sister followed Sally's tracks—right to a rock at the river. There, it was decided, Sally had taken a fatal leap at a swimming hole in the woods of Wise County. A diver soon retrieved Sally's body, but it was not the last time, some say, that Sally would be seen—or heard.

One night, some boys—knowing nothing of Sally—went down to the same swimming hole. There, they noticed a crying girl, dressed in white. She stood on a rock, lifted her arms to heaven and plunged into the river. This girl popped out of the water, like she was drowning. And one of the boys rushed over, reaching out to help. But then, he would find, there would be nothing to grab.

On later nights, more continued to hear howls at what became known as Wise County's haunted swimming hole. Others, too, said they could see the ghost of Sally, standing on the rock and her arms lifted to heaven just before taking yet another final plunge into the Powell River.

SONG IN THE BREEZE

Country Cabin of Norton—Josephine, Wise County

Kate Peters Sturgill practically breathed the ballads of the ancient Appalachians. She was a natural-born mountain musician, a quiet lady and sweet. She sang in churches, wrote songs and kept her guitar tuned to the tone of her own voice.

Born in 1907 at a Wise County coal camp called Josephine, Kate played piano about as soon as she could talk. She married a coal miner when she was a teenager, and she had children. She also had her music, and she knew that music was best when it could be shared.

Kate played in a string band in 1927. Then, in the dark days of the Great Depression, she made plans for her community to gather and hear songs, winning help from family and friends to construct Josephine's Recreation Center.

Musician Kate Peters Sturgill (1907–1975) founded the original Country Cabin in the Josephine section of Wise County, near Norton. She was a songwriter, known for such compositions as *A Deep Settled Peace. Courtesy of the Country Cabin.*

Built in 1937, this quaint cabin rose beside a mellow stretch of the Powell River. Eventually dubbed the Country Cabin, the pole log building was the site of square dances, games and fast-fiddling music. It would, in time, become no less than an institution, and, in 2001, spawn a successor: the larger Country Cabin II, standing near the original cabin, not far from Norton; the place offers regular Saturday night shows that have become an integral part of the Crooked Road: Virginia's Heritage Music Trail.

Only, Kate would not know any of this—at least not in life. The Country Cabin lost its original purpose by World War II, hardly more than a few years after it was built. No longer a social gathering place, it became a mattress factory and also a rental home, tucked beneath a bevy of pine trees. By the time of her death in 1975, Kate must have felt like at least one dream had been dashed—or that she had stopped strumming a song before its end.

In 1978, the cabin's original intent was resurrected. It again became a place to clog and a gathering spot for people to make both apple

The original Country Cabin was built in the late 1930s with help from the Works Progress Administration. It was initially used as a community center, where musician Kate O'Neill Peters Sturgill taught guitar lessons. *Courtesy of the author.*

butter and music. At least twice, too, it's believed that Kate returned—like a song in the breeze.

A longtime Country Cabin supporter noticed Kate's spirit one night in 1980. White light surrounded her ghostly form—sitting on a bench, with her arms crossed, watching musicians perform on the original Country Cabin stage. Kate's ghost stayed for about three minutes, it's told, and not much later she appeared again outside, this time at a homecoming festival. Of that second time, like the first, it's said Kate again wore a grin, apparently happy that old mountain music could be shared.

CURSE OF THE COFFIN

University of Virginia's College at Wise—Wise, Wise County

Not everyone—or maybe not anyone—could afford a casket at the Wise County Poor Farm. This was, after all, a home to the homeless, the unfortunate—and, yes, a few wayward women. For years, poverty-stricken souls of Wise County lived, died and were buried here.

Now, in the afterlife, these souls—restless in spirit, perhaps even before death—have seemed to appear again.

For years known as Clinch Valley College, the University of Virginia's College at Wise moved to the grounds of the poor farm when the school was established in 1954. Then, as the college grew by 1957, it was deemed that more space—on Cemetery Hill—would be needed to erect new buildings. That meant moving graves, some from the poor farm and others from a private plot.

At first, college officials had no idea how many graves had to be moved. Estimates grew continually, starting with an initial guess of forty and eventually climbing to the reality of moving more than one hundred.

Today, some believe, not all graves have been found—and the remains of some lost souls could lie on Cemetery Hill beneath Zehmer Hall and the nearby John Cook Wyllie Library.

Librarian Anne Duesing worked in the basement of the library one night during 1997. And as the clock approached 1:00 a.m. she heard footsteps—mysterious footsteps. The librarian called the campus police. Then she bravely decided to follow the stepping sound. Slowly, she eased around a bookshelf. And then she saw *it*: "a white skirt swirling around. I didn't see the body," she said. "I just saw the white skirt. I just saw it going!"

This frightened librarian checked out of the library. And after that she swore to stop working so late, realizing that she must have witnessed the lady in white, an apparition previously reported by a custodian. It's believed to be the spirit of a woman whose grave was not found or, perhaps, one who resented having her final remains removed.

Wakes on the poor farm were routinely held at Crockett Hall, a stone structure standing since 1924. This handsome building took its name from Sam Crockett, who played a key role in establishing the college. It was once a residence hall and later became campus offices. Yet, in the days of the poor farm, it also morphed into a morgue: caskets would be opened, and the living would pay tribute to the dead. Still, some coffins were not buried but used again—over and over.

Charles Lewis discovered one such pine box in 1975. It had presumably stayed in storage for decades in the basement of Crockett Hall until Mr. Lewis, a theater professor, needed the prop for a production of James L. Rosenberg's *The Death and Life of Sneaky Fitch*.

Crockett Hall was built in 1924 on the Wise County Poor Farm and once housed a morgue in its lower level. It became the main building of Clinch Valley College in 1954. *Courtesy of the University of Virginia's College at Wise.*

Mr. Lewis was not superstitious—just a stickler for making sure all props were accurate, even a tiny casket. But perhaps this prop—this portal of the poor farm—should have stayed put.

That coffin had not been in the building a week, maybe, when students took note of an elderly gentleman dressed in old clothes wandering around the back of the theater building. "Everybody was seeing the same person, but he was not a person—not a theater patron, not a friend of anybody. People began seeing an elderly gentleman, especially in the hallway," said Jewell Worley, one of the college's drama students. "And so he became the ghost of the theater building that was associated with having lost his coffin."

Some say that coffin—what many just called the Box—would move by its own accord. The creepy casket still remains a valued prop in the college's theater department, though no one knows its true history: how it was used, if it was used or even if it might have once been buried. Theater officials do resist getting rid of it, though some also believe in a certain curse of the coffin: come into contact with it, it's told, and you may be afflicted with some bodily harm—perhaps a spirit of the Wise County Poor Farm.

GONE BUT NOT FORGOTTEN

*Breaks Interstate Park—Breaks, Dickenson and
Buchanan Counties*

Richard Potter climbed to the rocky pitch of Pine Mountain as early as 1821. He was an herb doctor. He built a log cabin for his wife, Teenie, and their ten children. Mr. Potter also grew particularly famous for making applejack, and, it's said, he had a habit of offering each overnight guest a glass of peach brandy.

By the time Mr. Potter died in 1882 at age ninety, he had acquired most of what is now Breaks Interstate Park—the home of a grand canyon at the northern end of Pine Mountain. By morning, clouds hover here along the Kentucky–Virginia border in a gorge, where the Russell Fork of the Big Sandy River chews boulders for breakfast. At midday, tumbling waters stay shrouded with the misty sprays of the river's tortuous course. Come suppertime, Pine Mountain's endless run of rocky ledges disappears—first from fog and then into darkness when the sun dissolves over Kentucky's western horizon.

Evergreens line the rocky Breaks Canyon in this 1931 photo by Akers West, showing the wild land along the Dickenson–Buchanan County border, about twenty years before Breaks Interstate Park was established in 1954. *Courtesy of Anne West.*

It takes more than the two Virginia counties of Buchanan and Dickenson

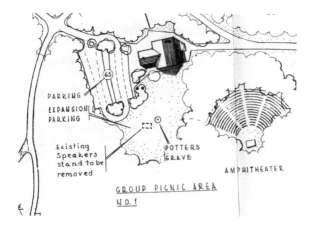

This 1956 map shows a proposed plan for Breaks Interstate Park. Notice a speaker's stand erected next to the grave of Richard Potter. The Potter's Knoll Shelter now stands in its place near an amphitheater. *Courtesy of Breaks Interstate Park.*

to contain Breaks Interstate Park. It also takes two commonwealths, Kentucky and Virginia. Breaks spreads into both states, with about five thousand acres, flanked by a tangle of trees at the westernmost terminus of the Crooked Road: Virginia's Heritage Music Trail.

In 1949, only a narrow, dirt road accessed this place when the governor of Kentucky made a speech at a speaker's stand on Potter's Knoll, the place where Richard Potter was laid to rest. Years later, at the site of that stand, a picnic shelter would rise—and, perhaps, so would something more.

Jerry Wolfe eyed that picnic shelter when a summer storm rocked the Breaks canyon with thunder in 1998. This middle-aged schoolteacher had come to the Breaks Interstate Park in good weather, riding his bicycle from his home in nearby Wise County. He figured he would set up his tent in the campground, sleep a night and ride home the next day.

Then the rain came, pounding like nails at his skull. Jerry stayed until closing time at the park's Rhododendron Restaurant. But finally, alone in the dark, he made a run to the Potter's Knoll Shelter—the first roof he could find. There, Jerry parked his bicycle and attempted to camp out for the night beneath a picnic table, knowing there would be no way he could assemble his tent and stay dry.

There was no one around.

Yet in the strike of lightning, Jerry could see something—some tall man, wearing a long coat and a western cowboy hat. Jerry couldn't

The grave of Richard Potter (1792–1882) lies just a few feet from the Potter's Knoll Shelter at Breaks Interstate Park. Mr. Potter, a farmer, owned land where the park was established on the Kentucky–Virginia border. *Courtesy of the author.*

make out who or even what it was. Yet each time the sky grew light, there was that ghostly figure: standing tall and moving closer, seemingly unaffected by the strong storm—or perhaps protecting his final resting spot.

Jerry got up and ran. He tore off down a hill, in the rain, and parked his back at the park's amphitheater. There, he would spend the night, wide-eyed and awake, but still staring at the shelter, too scared to go back and fetch his bike.

The next day, at home in Wise County, Jerry got chills hearing from a friend that many campers like himself, in the 1980s, had told of seeing the same kind of ghostly man at Potter's Knoll—not far from where Jerry had tried to sleep, beside Richard Potter's grave. Allegedly, this ghost showed up in storms, in the blaze of lightning. And it was never too far from the final plot of that Pine Mountain pioneer, buried with a simple tombstone, saying, "Gone but not forgotten."

CLAYPOOL CROSS

Cedar Bluff, Tazewell County

Nannie Ruth Lowe could walk and talk before she was a year old. Soon, she could read the Bible. By age three, she led the singing for revival meetings. But, one day, this little girl stood up. At age seven,

she said, "My mission has been brief, but it is finished, and I must go home to the Father."

Her family did not understand. Still, they hardly had time to contemplate. In another two weeks, on a December day in 1933, this girl was dead. Not only did Nannie Ruth's family cry—so did the two thousand people who attended her funeral at Cedar Bluff, a Tazewell County town named for the cedar trees growing on high bluffs above the Clinch River.

The following year, in 1934, Cedar Bluff won fame as the hometown of Virginia's newly elected governor, George C. Peery. Still, more attention remained on Nannie Ruth.

On January 11, 1934, Nannie Ruth's mother emptied the feathers of the pillow on which the girl had died. There, at the center, the feathers had formed the shape of a crown and a cross. Mystified, the girl's family saved the feathers and put them in a box. Yet they were equally perplexed when the cross *grew* from about six inches in length to two feet in a year's time!

Eventually, thousands came to see this Claypool Cross, named probably for Cedar Bluff's proximity to the nearby community of Claypool Hill. In later years, too, another story would be told of Wise County's Maggard Death Crown, also formed from the feathers of a pillow. Like the Claypool Cross, it was thought that this death crown—in the ancient beliefs of the Appalachians—was a sign that the deceased had entered the gates of heaven.

GHOSTS OF GREYSTONE

Greystone Bed and Breakfast—St. Paul, Russell County

Like a mansion of mystery, Greystone overlooks both St. Paul and Castlewood. It's a ten-thousand-square-foot home, rising three stories, built with ornate front-porch columns and loaded with the limestone of a nearby quarry. For years, this private palace's sheer size—and its looming location atop a grassy knoll—has bemused outsiders, with many wondering what lay inside or, even, who haunts it.

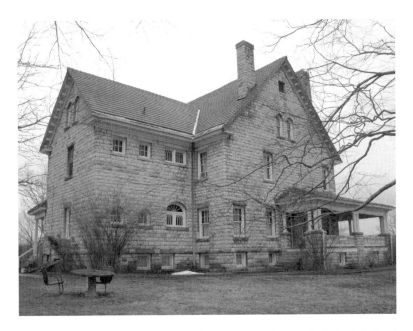

In Russell County, the privately owned Greystone mansion overlooks both St. Paul and Castlewood near the banks of the Clinch River. The stone castle was built in 1908 for businessman James E. Duff. *Courtesy of the author.*

Greystone took its name from Walter Grey, who purchased the Russell County home about a decade after it was built in 1908. Many years later, members of the Grey family rented Greystone as apartments. At that time in the early 1970s, Bill Hileman handled maintenance, and, at least once, he recalled the spooky sights of doors opening and closing on their own—and hearing mysterious footsteps on the sets of stairs.

Sometimes, now, Greystone does appear to talk, with radiators producing a snap, crackle and pop while the winds of the west whip windows, rattling like chainsaws. Such sounds, surely, could have been unnerving to apartment dwellers and, in later years, to the visitors of Greystone Bed and Breakfast, operated by the Gordon family in the mid-1990s.

Guests occasionally reported ghostly sightings. In this era, too, the youngest member of the family, Maddie Gordon, at age seven, first revealed her sightings of Mr. Black, an ever-roaming ghost and

31

apparently the shade of James E. Duff, the man for whom Greystone was built.

Mr. Duff was a partner in a large lumber company in Scott County, Virginia. He wore dark clothes, had dark hair and liked to ride a white horse. The man died in 1911, hardly a couple of years after spending $40,000 to build Greystone, a place where he had employed the skills of stone masons and carpenters to create a maze of hallways, wandering off in many unusual directions and hiding rooms around nearly every wall.

Inside this mansion, and among the lovely grounds of Greystone, Mr. Duff now appears to wander and hide as Mr. Black, said Raleigh Clark, Maddie Gordon's ten-year-old sister. "I see him walk around the house in a big, black jacket. His face is all in black. That's why we call him Mr. Black, because he's all in black—a black trench coat and a black hat," Raleigh said. "He doesn't make any sound when he walks."

Raleigh's description of Mr. Black matches what older sister Maddie has seen: a shadow figure. "I wouldn't call it a haunting," the twenty-year-old Maddie Gordon said. "It's just a presence. There's never been anything bad happen or come of it. It's just seeing something that goes by."

The ghosts of Greystone might, actually, number more than Mr. Black. Maddie has also seen what appeared to be a woman in a window wearing a flowery dress and a ghostly gray-haired man wearing a white sweater. Additionally, while this house operated as Greystone Bed and Breakfast, members of a church group once abruptly escaped in the middle of the night, leaving behind their luggage and saying they could hear demons screaming in the wall.

On a different night, a regular patron of the bed and breakfast awoke on the bed of the Blue Room when, he said, a door to the balcony blew open and in walked a woman wearing a flowing gown. This ghostly lady, the man said, soon disappeared. But, later, so did this middle-aged businessman; it would be the last night that he booked a room at the Greystone!

HOLSTON VALLEY

Hiltons—Mendota—Bristol—Abingdon—Emory—Saltville

Spooky Sam

U.S. Highway 58—Hiltons, Scott County

As early as 1796, settlers staked claims along the North Fork of the Holston River. They built homes at what later became Hiltons, a Scott County village named for a local Hilton family. One particular cabin remains from that era, built just above the floodplain with huge logs of yellow poplar.

The cabin stands between the McMurray Grocery at Bruno and the river's U.S. Highway 58 bridge. And it's where a Union soldier was hanged for stealing food during the Civil War at what was once a dogtrot—a space between two cabins and what has since become an extended nook of a kitchen.

Charles and Linda Burkett have restored this riverside cabin as a fashionable showplace. Yet they have also lived with the legend of spooky Sam, the Union soldier whose spirit is believed trapped within their walls. "There seems to be a presence here that's unexplained," Linda Burkett said. "There are lots of strange noises in the house."

The previous owners—the McCrary family—heard mysterious sounds. The Burketts, in turn, have blamed Sam for footsteps on wooden floors, lights that apparently work on their own and even phantom flushes of a toilet.

The North Fork of the Holston River flows, at right, past the lawn of the privately owned Burkett home, a Scott County log cabin dating to 1796 along U.S. Highway 58 between Bruno and Hiltons. *Courtesy of the author.*

BRIDGE OVER TROUBLED WATER

North Fork of Holston River—Mendota, Washington County

Like a chain gang, prisoners toiled in the troubles of locating a line of railroad tracks. It was 1879, and one crew worked its way through the jungles of Wolf Run Gorge to reach the mountains of Mendota, a Washington County town where the North Fork of the Holston River takes a mighty turn.

These prisoners slaved for free, slicing down trees and moving rocks while preparing a flat grade for what was then known as the Bristol Coal and Iron Narrow Gauge Railway. Coming from Richmond, Virginia, the convicts were forced to survey some of southwestern Virginia's deepest, darkest forests. Making their way from Abrams Creek to Mendota, they would also have to cross the North Fork.

There, one prisoner engineered an escape; if caught, his sentence would be doubled. Still, he took a leap—and then died among the rocks of the river. Now, some believe his spirit remains, haunting that bridge, long after rail cars have stopped rolling across the tracks.

The initial work by these prisoners ended in about 1882, leaving this line unfinished. Work resumed in the late 1880s, and the rail line became part of the South Atlantic and Ohio Railroad, eventually incorporated into the Virginia & Southwestern Railway Company in 1899. This same railroad also became part of the lives of the Carter Family, pioneering musicians, who lived along the tracks at Maces Spring, between Mendota and Hiltons, in the 1920s.

By the mid-1970s, railroad commerce dried up. A scenic excursion train briefly operated on the tracks. Later, it was proposed to make the old line the Mendota Trail, a rails-to-trails project. But squabbles

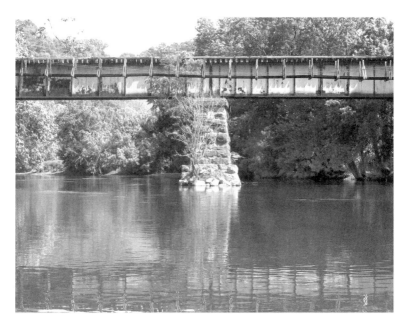

Inaccessible by land, the Mendota Trestle over the North Fork of the Holston River was once part of the Virginia & Southwestern Railway. The abandoned bridge was later proposed to be part of a rails-to-trails project. *Courtesy of the author.*

with landowners squashed trail-building plans. And places along the railroad—like the haunted bridge crossing the Holston River—would remain isolated and nearly impossible to access.

Maybe that's a good thing, for this could really be a bridge over troubled water. It is told that some campers once pitched a tent on a farm near the now-abandoned span. But a strange light appeared beneath the water and would continue to trouble them, just yards from a set of shoals.

WAITING FOR A TRAIN

Bristol Train Station—Bristol

Arthur Slaughter grew up riding the train connecting Mendota to Bristol, a two-state town sprawling along the Tennessee–Virginia border. Born in 1906, this farm boy from Washington County learned to make money trapping muskrats and skunks. In later years, he would control businesses all over Bristol and own natural gas wells. Still, there was one structure—the Bristol Train Station—in which he took a particular pride for sentimental reasons.

George W. Pettyjohn, Arthur's grandfather, had served as the station's construction superintendent; his great-uncle, John Pettyjohn, was the builder. Naturally, then, Arthur Slaughter would have loved the Bristol Union Railway Station. It marked the fourth railroad station to stand in Bristol—a true train town, where the railroad arrived in 1856.

This twin city, with a Bristol in Virginia and another in Tennessee, takes its name from Bristol, England. Its first depot was burned during Union general George Stoneman's raid on December 14, 1864, during the Civil War. A second station was replaced by a third after 1881. Then came the Union Depot, the one owned by Arthur Slaughter, built with bricks and stone in 1902.

Passengers came and went. Among them was Jimmie Rodgers, the Father of Country Music, who arrived at the Bristol station in August 1927 and walked into country music history by recording

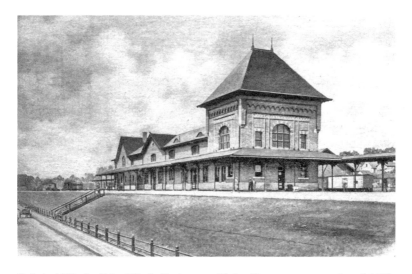

Built in 1902, the Bristol Train Station—or Union Depot—was owned until 1999 by Bristol businessman Arthur Slaughter. This depiction, once circulated as a postcard, shows the station soon after its construction. *Courtesy of George Stone.*

his first two songs, *Sleep, Baby, Sleep* and *The Soldier's Sweetheart*, at a makeshift recording studio in Bristol, Tennessee. Rodgers became the Father of Country Music, and Bristol, in turn, became country music's birthplace and a cornerstone along the Crooked Road: Virginia's Heritage Music Trail.

Still, the complexion of Bristol changed when passenger trains stopped running in the late 1960s. And that, according to legend, signaled the end of one train station ghost: Chalmers King, a man who had lost his true love. Mr. King's girl had moved out of town in the mid-1800s. Soon after she did, he turned to a bottle for comfort. He died in 1880 and then returned as a ghost—for years, it was reported—even finding his way into the Union Depot. Still grieving in heartache, Mr. King was said to wear black pants, a white shirt, a bowtie and a derby hat. He would appear to be waiting for a train, looking for his lady—then disappear.

In the 1980s, the station had been developed into a shopping mall with business names like Sidetrack Tobacco and the Third Rail Cafe. Arthur Slaughter acquired the property by 1990. Yet this hulking building fell into a state of disarray and decay, as did

Arthur's health. The old man slouched over as he walked and did not easily get around.

Arthur Slaughter sold the train station in 1999 to civic leaders, anxious to restore the structure. The nonprofit Bristol Trainstation Foundation paid him $600,000. Then he turned around and gave $20,000 back to the foundation as a donation. Arthur said he hoped the station would be converted into a country music museum to celebrate Bristol's links to the likes of Jimmie Rodgers.

It took another $4 million to renovate the structure over the following decade, not as a museum but as a meeting place. Along the way, an ailing Arthur died in 2004.

Strange things began to happen after the building was restored. An antique clock mysteriously stopped running; several vases shattered; a wine glass exploded; odd drafts blew through the building; and the elevator seemed to run on its own.

Then the cough came. Some invisible spirit entered the great room of the station on November 28, 2008, according to train station manager Brad McCroskey, and its footsteps appeared to walk through a table at the center of the depot floor. Brad ran to a balcony to see who was there. He heard a distinct cough of what sounded like an older man clearing his throat. The station manager ran all around the building, inspecting everything. He found nothing but locked doors.

Ghost hunters later paid a visit, and one mentioned the former owner of the train station. At that moment, Brad felt an unnerving sensation, as if he had lost his breath. His chest grew heavy, he said, and he was unable to move. All agreed: Brad's breathing dilemma could be a sign.

Simply add the cough and the footsteps, that elevator shuttling unseen passengers and even the sounds of a disembodied man's voice; it would appear something—or someone—lingers. Perhaps, if it's not the ghost of Chalmers King still waiting for a train then, as some suggest, it could be the spirit of Arthur Slaughter.

GHOSTLY GALLOP

Martha Washington Inn, 150 West Main Street—Abingdon, Washington County

James Wyatt was more than mad: this Union captain aspired to make fire at his former residence—Abingdon, the courthouse town of Washington County. Captain Wyatt had marched into Abingdon as part of Union general George Stoneman's raid across southwestern Virginia in 1864. Then lingering, as December 14 blurred into December 15, Captain Wyatt carried out a plan of revenge.

Abingdon served as an important supply center during the Civil War. That's why General Stoneman made it a point to stop here before advancing on the salt deposits of Saltville. During that time, salt was paramount to keeping troops fed, being used to protect meat before the advent of refrigeration, and Saltville—lying on the border of Smyth and Washington Counties, and not far from Abingdon—had earned a nickname as the Salt Capital of the Confederacy.

General Stoneman ordered his ten thousand troops to burn whatever the Confederates might use in Abingdon: the railroad depot, barracks and storehouses. But some Union soldiers got carried away in the raid and broke into a home where a wedding was set to take place the next day. One officer slipped on the bride's bonnet; more sliced the wedding cake with a sword. Later came James Wyatt, lone and disgruntled. And he would do more.

Several Southern soldiers continually fought back. During the war, some used a tunnel under the town to run guns between a temporary hospital—the Martha Washington College for Women—and what became the Barter Theatre, a building on Main Street, then used by the Sons of Temperance. Union forces caught wind of all this, however, and shot two soldiers, leaving them dead in the tunnel.

Legend now says that those soldiers' spirits remain, even if the tunnel doesn't; it has collapsed. But a part of it still survives as a crawlspace in a storage area connected to the Barter Theatre's Scary Room, a basement-level bunker that has tormented the theater's actors for decades. Many believe the Scary Room is haunted by a

The Martha Washington Inn on Abingdon's Main Street was known as the Martha Washington College for Women when this picture was made sometime after 1870. *Courtesy of George Stone.*

benign presence—something not necessarily seen but felt. As late as the 1990s, that presence has manifested itself, too, scaring a group of four construction workers at 2:00 a.m., horrifying them enough to leave and never return to the job of renovating the theater.

Just across Main Street, the Martha Washington Inn occupies an 1832 mansion that once housed the Martha Washington College. During the Civil War, college classes struggled to continue; students became nurses, and they, in turn, fell in love with soldiers. But those young ladies also watched those soldiers bleed with wartime bullets and leave bloodstains that would allegedly never disappear. Years later, long after the war, these college girls would share spooky stories—including the haunt of the horse that trots down Main Street, dashes up a lawn and disappears.

Some say this horse belonged to Captain Wyatt, that vengeful young man who just would not leave town. Straggling behind General Stoneman's raiders, Captain Wyatt broke into the courthouse and set fire to the fourteen-year-old structure. He did offer an explanation, saying he had been punished by Noble I. McGinnis, a member of the county court, for an offense of which

he was "not guilty." Captain Wyatt also blazed other buildings along Main Street—and then, finally, draped one leg across the horn of his saddle as he watched Abingdon burn.

A couple of Confederates came charging through town on horseback, wearing partial Union uniforms. Captain Wyatt must have thought these brothers were on his side—until he was shot out of the saddle, not far from the college. Soon, that shot would kill the captain. His poor horse was captured, according to one account; another story says the horse fell; still more believe the animal wandered around the college campus for hours or even days and then ran into eternity with a ghostly gallop.

Sightings of this supernatural steed did not disappear when the Martha Washington College closed in the 1930s. Guests of its successor, the Martha Washington Inn, would report seeing a horse that runs and disappears, allegedly on both moonlit and moonless nights.

Still more say this haunting horse might belong to yet another wartime casualty: a Union soldier who had come to burn an old carriage house that was allegedly loaded with ammunition. That soldier, according to legend, was shot near the college. And, like Wyatt, he died when this town turned upside down.

WHAT BECKONS AT BYARS

Emory & Henry College—Emory, Washington County

Overheated with emotions, a couple of college students tore at each other—rushing, rolling and fighting. They debated to the death. And, it's said, the spirit of one student still makes a hanging light swing, even when the wind doesn't blow.

So goes one longstanding legend of Byars Hall, a prominent landmark on the campus of Emory & Henry College. One of the oldest schools in Virginia's Blue Ridge Highlands, this Methodist college takes its name from both Bishop John Emory and Governor Patrick Henry—or perhaps Henry's sister, Elizabeth Henry Campbell Russell, who lived for many years in nearby Smyth County.

Outlined by oaks and crisscrossed by sidewalks, this campus has collected an assortment of ghost tales, from an unexplained light floating above the Emory cemetery to phantom footsteps heard on the stairs of the J. Stewart French House.

What beckons at Byars provides another mystery at Emory.

The original Byars House burned twice in the 1850s. A new Byars House, built on the same ground, burned in 1889. The current Byars Hall stands on the same spot as the Byars House and took its name from Colonel William Byars, one of the college's founders. His name had been placed on the original Byars House when it was constructed soon after the college was founded in 1836.

Many students say Byars Hall harbors a negative feeling. Perhaps that comes from the ground's many fires. Or perhaps, some suggest, these are the leftover energies of the college's literary societies: the Calliopeans and the Hermesians, both groups that flourished on campus in the late 1800s and early 1900s; both are now defunct.

Byars Hall took its name from Colonel William Byars, one of the founders of Emory & Henry College. The brick structure was built after the Byars House, standing on the same spot, burned in 1889. *Courtesy of the author.*

But, at Byars Hall, each society still bears its own meeting room, decorated with eerie letters and odd symbols.

Students took these societies seriously. Some debates, especially in the Calliopean Society, lead to threats—and at least one death. John B. Brownlow reportedly clubbed James W. Reese, a fellow student, in February 1860 when a contest for the society's presidency grew horrifically out of hand. Mr. Reese did not die immediately nor did the fight take place in Byars. It is also not known if this incident involved any kind of swinging light.

Yet the Calliopean Society then had—and still has—a meeting room in a hall named Byars. And, likely, this is how Byars Hall's famous story of the swinging light originates.

As it's told, one student fell out a window. But, just before falling, he grabbed that light. And now? Well, that light starts swinging for no reason, even when the wind doesn't blow, like the spirit of a great debate lives on.

SPOOKINESS OF SALTVILLE

Madam Russell Memorial United Methodist Church—Saltville, Smyth County

Her brother was Patrick Henry, the man who cried, "Give me liberty or give me death!" in 1775 at St. John's Church in Richmond. Her daughter was Sarah Buchanan Preston, a wife and mother who lived in the mansion that became the Martha Washington Inn of Abingdon. Her husband—well, actually, those numbered two: first, General William Campbell, a hero of the Battle of King's Mountain, and second, General William Russell. This woman would call herself "the wife of two generals." But, really, Elizabeth Henry Campbell Russell had a life of her own.

Born in 1749 at Hanover County, Virginia, Elizabeth became known as Madam Russell—the madam title given for respect. She converted to the Methodist faith in 1788 at the home of Stephen Keywood, near Emory, and helped spread that faith to all who listened and prayed with her in the Holston Valley near her home at Saltville.

Madam Russell lived at the edge of a swamp—a lake, actually, and one that no longer exists. This body of water lured woolly mammoths to its shallow depths about thirteen thousand years earlier. But in Madam Russell's day, in the late 1700s, this lake marked a valley where salt would be manufactured.

Here, at what was once called the Salt Works, Madam Russell often hosted pioneer itinerant Methodist ministers in her cabin, built in 1788. She prayed for—or with—anyone who walked in the door. Later, in 1812, the twice-widowed woman moved to what is now Chilhowie, Virginia. She died in March 1825 and was buried, initially, in Saltville and then was reinterred in about 1842 at Aspenvale Cemetery in Smyth County, one row above her first husband, General William Campbell.

Still, something—or some spirit—appeared to remain at Madam Russell's Saltville cabin, either leftover from those itinerant ministers or perhaps Madam Russell herself.

In about 1845, a Taylor family lived in the cabin, a time when the lake still covered the valley floor. One sunny afternoon, Mrs. Taylor, the mother, told her daughter and a visiting girl that they could eat a peach—but only one—or, else, the "silk petticoats" would get them. As it went, these girls got their peaches. Then, in disobedience, they decided to grab one more. Yet just as each would reach for a peach, it's told, they distinctly heard the phantom petticoats coming to the head of the steps.

Such spookiness of Saltville did not disappear, even though the lake did when Colonel Thomas Preston drained the Salt Valley in the late 1840s to build a road. Many years later, around 1900, a different family—the Burtons—inhabited the allegedly haunted house that once belonged to Madam Russell. This time, the young girls of the family—especially Nannie Burton—would tell of hearing preaching and singing upstairs, like people muttering Bible verses or singing hymns, especially on religious holidays. Finally this family fled, unable to find peace in the home.

Then, as if no one wanted to live there or perhaps faced too much fright to spend the night, the cabin became a barn until it was razed in 1908. A historical replica rose on the ground in 1974, erected within sight of where the original cabin stood. There, today,

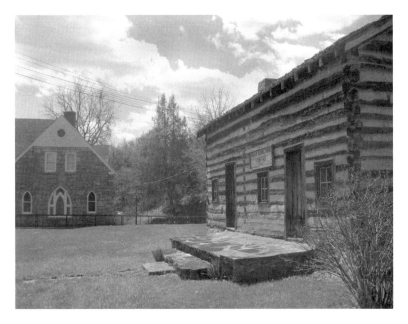

A replica of the Madam Russell Cabin, right, stands in the side yard of the Madam Russell Memorial United Methodist Church, left, at Saltville. The original cabin, torn down in 1908, stood between the two modern structures. *Courtesy of the author.*

weeping willows cast shade on a lawn and a parking lot behind the stone structure of the Madam Russell Memorial United Methodist Church, constructed in 1898.

Maybe that church has inherited the spirits of the old cabin.

Here, at 8:00 p.m., during a church renovation project in 2005, member Bob Maule heard what distinctly sounded like a rocking chair, making a seesawing grind against the wooden floor above him. Bob asked, "Who is it?"—and the sound stopped. Then, it started again, and he left, saying, "I just didn't have enough guts to go upstairs."

Around that same time, Fred DeBusk went to work in the church attic, installing lights. For three weeks, this Saltville handyman experienced nothing unusual. On the last day, quite casually, he looked around the attic and said, "I guess there's nothing here." But there *was*—or, at least, there was enough there to give Fred "a rush, like a thousand needles all over my body," he said. "I never saw anything or heard anything. But there was a presence."

CENTRAL HIGHLANDS

Bastian—Wytheville—Grahams Forge—
Independence—Hillsville

THE INDIANS ARE LAUGHING

Wolf Creek Indian Village—Bastian, Bland County

It's a faint sound that appears to come from the distance along the clay banks of Wolf Creek. In the breeze, the guides of the Wolf Creek Indian Village hear children playing. And they hear women giggling, gathering sticks and talking, almost like twittering, buzzing among the bushes of Bland County.

The guides hear voices, speaking a language they don't understand and talking when no one else is around. "And the first time you hear it, you get creepy," said longtime guide Denise Smith. "It's a creepy feeling to hear it, because you're looking for somebody to be here to talk to. And then you turn around, and there's no one there."

These are the ghosts of the Wolf Creek Indian Village, what's believed to be the spiritual remains of Native Americans who lived along Wolf Creek hundreds of years ago. Less experienced guides at this Native American village replica have heard the ghostly voices, gotten scared and refused go to this village alone. Others have simply accepted the presence of people they cannot see, as if the unexplained voices are guardians, encouraging the guides to show off this re-creation of their village, dating as early as 1400.

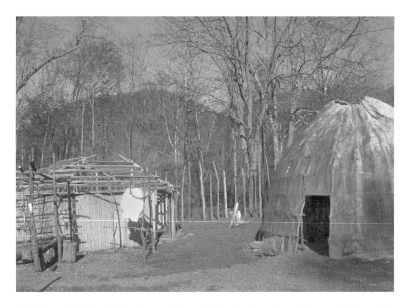

Wolf Creek Indian Village is a replica of a Native American village, which stood along the banks of Wolf Creek in Bland County in 1400, though archeologists once dated it as early as 1215 AD. *Courtesy of the author.*

Evidence of that ancient village remained when archeologists mapped its contours in 1970, just before the construction of Interstate 77. But that road project required rerouting Wolf Creek, a stream that would have once provided sustenance as a place to fish, bathe and catch crawfish.

That construction, in turn, disturbed the village's ancient Indian burial site, and scientists scattered its skeletons to various institutions like the Smithsonian. The reconfigured Wolf Creek now rolls across a portion of the ancient village—and even across the sites of graves.

In all, fourteen graves were removed, including men, women and children. And that, according to Native American belief, has interrupted the afterlife journeys of the ancient people.

Only the remains of one grave were returned: a canine. That animal's bones now lie at an undisclosed location near the village replica, constructed in the mid-1990s as an educational facility, about two hundred feet from the site of the original village. This dog—or what was possibly a wolf—is now believed to be the spirit

that protects the village. Even so, its presence appears to make dogs visiting the village nervous, holding down their ears and tails.

All the while, it appears, the ghosts of the Indians are laughing.

Once, Denise Smith and another guide, Penny Plummer, tried to find the source: The pair ended up along Wolf Creek. But there, instead of finding what made the giggles, these women discovered a perfect vein of clay, what turned out to be exactly what they needed to construct the kinds of bowls and vases to match the ancient pieces of the original village.

"It's as if the spirits are here to help us. And, sometimes, I think they're laughing at us. I think they're kind of tickled that we're rebuilding their village," Denise Smith said. "Now think about this: You existed five hundred years ago and died on this spot. And you've got these people—five hundred years later—rebuilding your village. That has to be a good reason to be back."

GHOSTS IN THE GHOST TOWN

Virginia City, U.S. Highway 52—Wytheville, Wythe County

Bad luck—actually, a tragic train of death and debt—has plagued the site of Virginia City almost since its beginning. This Wythe County attraction was once called Dry Gulch Junction: it was an amusement park billed as a Ghost Town.

Run-down and then restored, it became Virginia City, a western-theme site luring visitors to its collection of nineteenth century structures: a chapel, a general store, a jail and a mill, all rescued from sites across Virginia's Blue Ridge Highlands.

Dry Gulch Junction was promoted in the late 1970s as Virginia's Only Ghost Town. But, perhaps, with all its misfortune, it's a ghost town that might have its own ghosts. "There are people that swear the place is haunted," said Connie Janowski, a former Virginia City manager. "If you sit quietly on the porch, you'll hear all kinds of strange noises in these buildings."

As early as the 1960s, Stuart Kime dreamed of turning raw mountain land into an attraction. In the late 1940s, this businessman

had already established Big Walker Lookout on the Bland–Wythe County line, eventually building a chairlift, a swinging bridge, a restaurant and a one-hundred-foot-high lookout tower near the site of an old beer hall. The Pennsylvania native was a true workhorse, too—always thinking of something new, like adding yet another attraction to lure tourists.

So Stuart set his sights on a Shay, a 1905 steam locomotive. It would be used to pull the passenger train of Dry Gulch Junction.

That Shay became the centerpiece of Stuart's make-believe town, surrounded by the slopes of the Jefferson National Forest and inspired by Stuart's trips out west to view real-life ghost towns. Stuart's tiny train would haul visitors on a scenic, V-shaped excursion, going up Big Walker Mountain to demonstrate the path of an actual logging train.

All along, Stuart Kime rallied to have Interstate 77 built through Bland and Wythe Counties. Even so, that same span would nearly spell a death knell for his business ventures along the parallel path of U.S. Highway 52.

Traffic shifted—dramatically—when the new road opened in 1972, leaving U.S. 52 nearly deserted and Stuart Kime's businesses

The late Stuart Kime brought the steam train to the mountaintop attraction of Dry Gulch Junction in the 1960s. The train was removed after the park closed in 1981. *Courtesy of the author.*

at a standstill. Perhaps overcome with shock, the dreamer and builder died within months at age sixty-four.

The following year, Stuart's son Ron Kime vowed to finish building Dry Gulch Junction around his father's train tracks. Dry Gulch Ghost Town, as it was sometimes known, would soon boast a strolling magician, saloon shows and simulated gunfights, with stunt men falling off two-story roofs yet never getting hurt. Still, the spirit of its founder, Stuart Kime, must have hung heavy—not just when times were happy but also sad, like the tragedy of July 15, 1979.

On that Sunday at 3:10 p.m., Stephen "Steve" Hamilton spread sand on the railroad tracks to increase the train's traction. Big and jolly, Steve was well loved among all at Dry Gulch Junction, especially musicians; the Indiana native was the director of a community band. Regularly, Steve stood on the platform, spreading sand, at the front of the locomotive. But, on July 15, Steve must have lost his balance. In the heat and steam, he fell under the locomotive and was killed instantly at age twenty-seven.

The *Southwest Virginia Enterprise* called it a freak accident and noted the engineer "was unaware of what had happened until he felt the guide wheels run over an object."

Then the rain came. Like the heavens cried for the music man, bad weather rained out nearly an entire season's worth of country music concerts. Ron Kime and his wife, Dee, figured it could not rain at every show; but it did, or, at least, it seemed that way. Once, too, there was even snow at a show.

All that rain put the Kimes in financial hot water, and Dry Gulch Junction had to be sold on October 22, 1981. Over the following two decades, the property's buildings stood deserted, as handmade windows were busted and copper was stolen for scrap. The scenic railroad was removed.

Dry Gulch Junction rose again in 2000 as Virginia City with the dreams of Michael Hill and Jeanne Davis. This couple rebuilt the old-timey structures; they also opened a gem mine; and it appeared that some kind of spirit might have helped, Jeanne said, as the couple lost tools. Then those tools would mysteriously turn up on the front steps of a building.

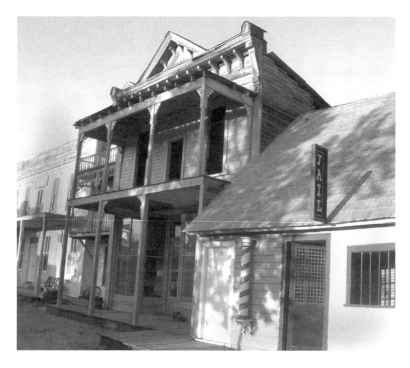

Antique buildings rescued from places across Virginia's Blue Ridge Highlands comprised the ghost town of Dry Gulch Junction, later known as "Virginia City." *Courtesy of the author.*

Tragedy, still, continued to haunt the old ghost town. Michael Hill suffered an extreme muscle strain after he struggled to save an all-terrain vehicle from being lost in the woods at Virginia City in November 2005. That strain turned into an aneurysm and, within weeks, he died at age fifty-five.

Sadness once again prevailed.

All the while, the Virginia City staff stood perplexed by the strange noises of the buildings, especially a scraping sound around the old general store. It was a screech, Jeanne said, whose source could never be determined—and a sound that left many wondering: are there ghosts in the ghost town?

WHAT'S YOUR NAME

Major Graham Mansion—Grahams Forge, Wythe County

Squire David Graham was rich. Stern looking and powerful, he controlled iron furnaces and forges all over Wythe County. Over a lifetime of seventy years, Squire David outsmarted his competitors and amassed a plantation with thousands of acres, slave quarters and a massive mansion that would ultimately include odd etchings on a window: what could only be the maiden name of his wife, Martha.

M. Bell Peirce signed that bedroom window glass—with no "Graham"—in 1864. That scratch leaves no explanation, but it has since inspired speculation that theirs was, indeed, a stormy marital relationship. And that maybe—just maybe—Martha Bell Peirce Graham stowed herself away in this room or even was locked up and controlled, like so many other possessions.

Certainly, the story of the Graham family—and their scary-looking mansion—matches the script of a great soap opera, combining wealth and brains, mental illness and a devilish work ethic. Squire David had his brick house built sometime after 1840 with a stoic sense of architecture, using large doors, wide windows and tall walls comprising a cold, hard style that may well personify his shrewd sense of business. It simply feels like a fortress, perhaps even a castle, from which Squire David could overlook his expanse of wealth.

In time, Squire David would have his name emblazoned on maps at Grahams Forge, and his son, Major David Graham, would be remembered at the location of this imposing mansion, Major Grahams. Originally called Cedar Run, this landmark would be listed on both state and national historic registers. Still, for more than thirty years in the mid-1900s, it would also be left for nearly dead when it was inhabited by a messy, obsessive and book-loving hermit.

The Graham mansion may not have always looked so foreboding, seemingly staring down from its high slope with a sneer. Parts of its original brick section dates to the 1850s, a time when Squire

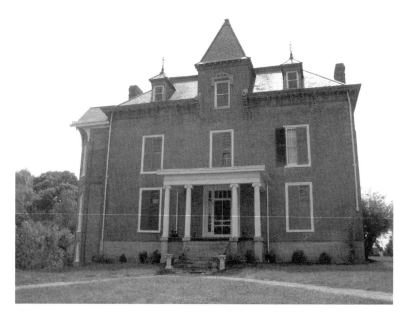

Major Graham Mansion of Wythe County, circa 1850s, was built in several stages, near Grahams Forge. It's listed on both state and national historic landmark registers. *Courtesy of the author.*

David, the father, forged a fortune. Major David Graham, the son, inherited the home in 1870 and imaginatively added Victorian-era detail, like a tower, dormers and Gothic ornamentation.

Now, it's believed this landmark must be haunted, not just by time and weather but by the Grahams, two slaves, possibly an orphan and maybe more. Even at midday it appears spooky, like buzzards should be circling its wrought-iron railings in the opening scene of a great thriller. The mansion stands uninhabited, exuding a certain negative vibe across its vast and empty rooms. At night, some say, Squire David Graham walks these halls, and his lingering spirit remains as angry as he looks in rare photographs, perhaps even angered that he had to die and leave this castle behind.

For years, people have reportedly seen faces in windows, detected strange lights and heard odd noises. Shadow figures have been sighted. Footsteps have been heard. And voices have been recorded, saying phrases like "Get out," "What's your name?" and the quite odd "I

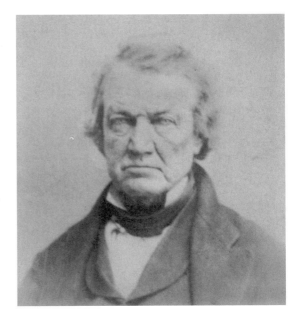

Squire David Graham (1800–1870) operated iron furnaces all over Wythe County, and his name is remembered on maps at Grahams Forge. *Courtesy of Mary Lin Brewer and J.C. Weaver.*

don't play that tune." Allegedly, temperatures change and people feel pressure in the basement—supposedly once a site to shackle slaves.

Blood spilt on this land even before Squire David Graham was born in 1800. The Graham mansion had risen at the site of a log cabin owned by Joseph Baker, who had promised to give freedom to two of his slaves. But those slaves grew impatient and decided cutting Mr. Baker apart would make them free in an instant. The slaves were subsequently sentenced to hang for this atrocity in 1786. But their souls, it is believed, still haunt the hill where the Graham mansion was built.

Long after Mr. Baker's murder, this monstrous house attracted the eccentric Reid Fulton, a scholar who bought it from a Graham descendant in 1943. Mr. Fulton walked without clothes, brandished a shotgun and lived without electricity, water, a telephone or central heat. He did love to collect books, however, and had thousands stuffed, floor-to-ceiling, on handmade shelves in every room. Yet he let the house deteriorate. Cardboard boxes, rags and chainsaws piled up, and one visitor in 1974 noted in a newspaper, "Fulton's sitting room looks as though he took up residence in a train wreck."

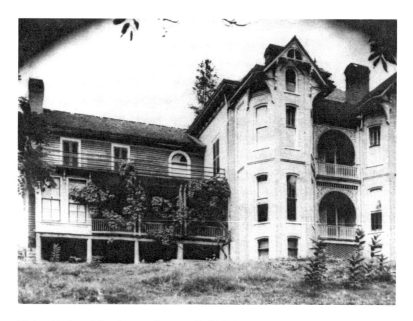

Major Graham Mansion was home to Reid Fulton, an eccentric book collector, when this photograph was taken, circa 1970, showing the side of the house. *Courtesy of Mary Lin Brewer and J.C. Weaver.*

By 1989, businessman and musician J.C. Weaver acquired the home and began restoring the structure. In came a clairvoyant, and out came tales of Clara—allegedly, the spirit of an orphan girl who lived at the home during the Civil War. It is believed that two of Squire David Graham's daughters, Bettie and Emily, kept this girl hidden in a second-floor classroom and tutored her along with other children.

No one, it seems, has proof that Clara even existed. And perhaps some will never believe this home is even haunted. But consider the story of the boy who challenged a ghost to appear on a tour and, according to eyewitnesses, saw a chair move on its own in 2007 and a mounted deer head fall from a wall. The startled crowd gathered around, needless to say, all made a run for the door!

THE JOURNEY'S END

Davis-Bourne Inn—Independence, Grayson County

Colonel Alexander Davis got out of an Ohio prison camp in the Civil War and made a journey to Grayson County in 1864. He dropped a load of dough on Emanuel Long: $410 of Confederate money. That sum secured the purchase of sixteen acres of land north of the Grayson County Courthouse.

The timing was of favorable fate for the buyer but not so much for the seller: Mr. Long held on to that money for another year and it would prove worthless at the war's end.

From here, it would seem Colonel Davis's luck would last. He made a living as an attorney in Independence; he dabbled in politics; he also took a bride, Mary Jane Dickenson, in 1865, and the couple had three children. But Colonel Davis would die young, at age fifty-six, and be laid to rest on the lawn of his property, near his home, overlooking the courthouse town of Independence.

The colonel's son, Garnett Davis, fashioned more than framework on his father's house. This pretty palace would eventually epitomize Victorian-era elegance, sporting a round tower, a twin parlor and a circular porch supported

A native of Smyth County, Colonel Alexander Davis (1833–1889) served Grayson County as a U.S. congressman. He made his home at what became the Davis-Bourne Inn of Independence. *Courtesy of Taphne Taylor.*

by classical columns. Along the way, Garnett Davis harnessed the power of a one-hundred-foot-long waterfall on nearby Peach Bottom Creek and provided electricity to the town of Independence.

J. Simm Bourne acquired the Davis property in 1930 but died only eight months later. His widow then sold the land to their children, including Pauline Bourne, a schoolteacher who lived most of her life inside this home that she called the Journey's End.

Studying law, Miss Pauline became an attorney, just like Colonel Davis. And, oh, she loved books. She hosted literary groups on the front porch and helped the town establish a library.

Miss Pauline died shortly after moving away in 1975 with her sister Mary. Sold again, the Journey's End became an office, a storage space and a meeting spot for senior citizens. A section of its grounds was used to build a new Grayson County Courthouse in 1979. Finally, it began a new life as a bed and breakfast in the 1990s. And, the staff said, along came some spirits—and much more than the wine served with dinner.

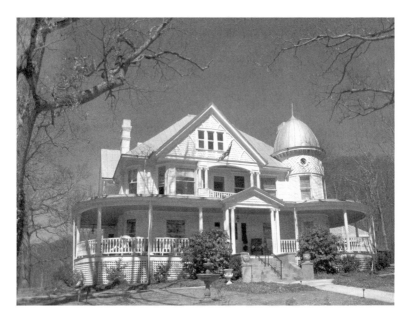

The Davis-Bourne Inn was built sometime after 1865 on a knoll overlooking the Grayson County courthouse town of Independence. *Courtesy of the author.*

More than once, mysterious smoke has been detected at the Davis-Bourne Inn. "I seen a great big puff of smoke, like somebody had blown out a puff of a cigarette," the lodge's assistant manager, Donny Collins, said. "But there was nobody else in the house."

Occasionally, too, lights blink—for three or four days—and then stop. Some say they feel like they're being touched as they climb the main stairwell. Kitchen items appear missing, only to turn up again, just where everyone had been looking. And once, it's said, a spoon in a punch bowl just started spinning on its own.

Several people have also claimed to hear the voices and laughter of women, what some believe is Miss Pauline. A former chef who spent the night claimed, "There were women in my room...I couldn't see them, but there were obviously two people carrying on a conversation at the end of my bed."

Likewise, that other attorney—Colonel Alexander Davis—is also believed to still be hanging around, according to Donny Collins. "It looked like I had seen him on the corner of the couch, and it looked like he was smiling. He was dressed in old clothes like what they used to wear back then, like in a black suit and black pants and a long coat."

Innkeeper Taphne Taylor, ever mindful of the evidence, ultimately would find herself making a declaration in Independence: She told any and all invisible inhabitants, "Don't scare me, don't scare my guests and don't tear up anything."

Yet any such fright might, she said, simply mirror a fleeting flight of fancy. It's as if these spirits have come to play or even just join the parties, basking again in the bright joys of good food and fellowship. Perhaps, for them, the Davis-Bourne Inn has become the Journey's End.

EARLY MORNING

Early—Hillsville, Carroll County

One night, at 2:00 a.m., the Worrell family awoke to the unmistakable sound of footsteps. It sounded like marching, going down the stairs, and then followed by knocking on the front door.

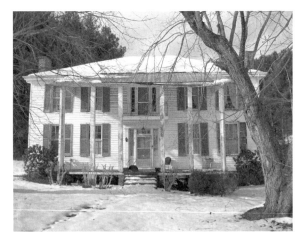

The James L. Early Home, built in the mid-1800s, stands along U.S. Highway 52 about four miles north of Hillsville. It was once the site of a post office called Early and also used as an inn. *Courtesy of the author.*

The Worrells lived inside the mid-nineteenth century homestead of James L. Early, a farmer and hotelkeeper. Mr. Early's spooky structure, a two-story house with blue shutters, stands along the snake-shaped path of U.S. Highway 52, just a few miles north of the Carroll County Courthouse in Hillsville. This house had once been the site of a post office called Early from 1899 to 1931; it had also once been an inn. Even as late as 1966, while a private home for the Worrells, indentations of room numbers remained on doors.

It was here that the Worrell family stood alarmed, hearing all these haunting noises: the footsteps, the knocking. And it made a repeat performance the following night at exactly the same time.

Waking up, that's when Woodrow Worrell, the father of the family, decided to set a trap. He poured flour all over the stairs, trying to track who or what might be making all that noise. On the third night, like clockwork, the footsteps and all that knocking happened again at 2:00 a.m. But when the Worrells came to see the flour, they found simply nothing—not one track!

Here happily, however, their story does end. That third time would turn out to be the final visit of what the family could only surmise was the early morning ghost of James L. Early.

NEW RIVER VALLEY

Buffalo Mountain—Shawsville—Christiansburg—Blacksburg—
Radford—Newbern—Wabash—Mountain Lake

BARK AT THE MOON

Buffalo Mountain Natural Area Preserve—Buffalo Mountain,
Floyd County

Buffalo once grazed at the base of Buffalo Mountain, a commanding rise providing scenic views for miles along the Blue Ridge Parkway and the Crooked Road: Virginia's Heritage Music Trail. For generations, Floyd County settlers have noted this humpback-shaped peak, named, actually, because it looks like the back of a buffalo.

Parents would once, naturally, tell their children they could roam wherever they wanted so long as they kept in sight of the Buffalo. But many might caution against roaming the highest reaches of this mysterious mountain, standing nearly four thousand feet.

Rattlesnakes claim the cavities of blue-gray rocks called Kettles, Raven's Nest and Rattlesnake Den. The Buffalo Mountain Natural Area Preserve, as well, provides a sanctuary for black bear, rare plants and an insect called the Korztarab's giant mealybug, found nowhere else in the world.

Still, strange lights have been seen flashing around a cemetery near Buffalo Mountain. And, it's believed, something other than an ever-howling coyote might appear to bark at the moon.

Rocks and trees cover the slope of Buffalo Mountain, a peak rising in southern Floyd County. More than one thousand acres of the mountain and surrounding land are protected in the Buffalo Mountain Natural Area Preserve. *Courtesy of the author.*

Here, it's told, a Cherokee Indian boy in the 1800s fell in love with a white girl. But that girl's family disapproved of their union, and her brothers ran to bash that Indian boy's brain out on Buffalo Mountain. Now, it's said, when the moon looks red, you can climb this rocky peak and still hear that Indian boy scream.

LEGEND OF WILLIE JACK

Camp Alta Mons—Shawsville, Montgomery County

At night, around the campfires of Camp Alta Mons, all ages wallow in the woes of Willie Jack. Legend says this maintenance man worked at the site of this Methodist camp during the early 1900s when it was known as Crockett Springs. And he could do anything, from fixing motors to cleaning floors. Willie Jack, unfortunately, fell down some stairs in the hotel near Shawsville.

Either that, or Willie Jack never worked here at all.

Some say Willie Jack was a hotel guest, old and crippled. One day during winter, he died. Being cold and icy, the hotel manager opted to stuff Willie Jack's body and his cane into a closet. There, it would remain for days, even weeks, until the spring thaw. But then, what happened when that locked closet was opened? Well, some say

Willie's body *disappeared*, never to be seen again except, of course, as a ghost, now wandering the woods of Camp Alta Mons.

Crockett Springs opened at the site of Camp Alta Mons in 1889. Its spring water had been discovered, according to yet another legend, when a sick Indian warrior had been left to die. That Indian drank the water from Crockett Springs and eventually recovered enough to rejoin his tribe.

In the late 1800s and early 1900s, the resort's owners claimed drinking or bathing in the arsenic-lithia spring water might cure insomnia, help seasickness and even improve a woman's complexion.

Crockett Springs closed in 1939, then the last operating spa in Montgomery County. The name Willie Jack would later hang as a sign on an old cabin at Camp Alta Mons, now practically all that remains from the old Crockett Springs Resort.

What does not remain, unfortunately, is any definitive version of Willie Jack's life or legend. To some, Willie Jack promotes Christian morals and values, maybe like a guardian angel around Alta Mons. It's been told that Willie Jack's spirit has helped—and continues to help—lost hikers in the woods. Yet, to others, Willie Jack's ghost hovers as an old man who haunts the camp—and hates kids.

BACK IN BLACK

Old Christiansburg Middle School, 208 College Street—
Christiansburg, Montgomery County

Just before dusk, it's told, all is quiet at the old Christiansburg Middle School except for *clickety-clack* footsteps, like a woman's high heels, and the sounds of slamming doors. These are said to be the spirits of some sinister siblings: three sisters who killed, controlled and left the good Christians of Christiansburg alarmed by a burning bed, an alleged insurance fraud and some mysterious graveside rituals.

These women mortified Montgomery County more than a century ago. And it's long been believed their souls are not done yet: their ghosts haunt the hallways of the ground where their school once stood on Christiansburg's College Street.

"I've heard doors slam and nobody here. And I've heard footsteps down the main stairwell," said school custodian Sue Robinette. "One time, they sounded like high-heels walking down the hall. And I looked, and there was nobody there."

But, once, there was somebody there: Virginia Wardlaw, Mary Snead and Caroline Martin. These women came from a prominent Methodist family and they ran a school for girls on this same hilltop until 1908. Their aunt Oceana Seaborn Pollock—so named because she had been born on the Atlantic Ocean—was revered in Christiansburg while leading this school in the 1870s. It was called several names: Montgomery Female Academy, Montgomery Female College, and sometimes simply Montgomery Hall. For a while, in the 1880s, Virginia Wardlaw taught here before leaving to teach in Tennessee. Virginia returned to Christiansburg in the early 1900s— and she came back in black.

Virginia and her sisters wore large black hats and black robes, and they shrouded their faces with long black veils. To the close-knit community of Christiansburg, these women became known as the Black Sisters, not for the color of their skin but because of their funeral-style fashions. It appeared these sisters stood in perpetual mourning. Or, as one reporter put it, "Perhaps they mourn for loved ones gone—or for those about to go."

Taking over what was once Oceana's academy, the Black Sisters developed a reputation as strict disciplinarians. Yet, that also meant scaring students by moving them from room to room, seemingly for no reason, or sometimes standing over a young girl's bed as she slept. The sisters installed excessive locks on doors. They also made late-night trips to a local cemetery, shuttled by a wagon driver, who would later tell the townsfolk that he had seen the Black Sisters gravitating toward a grave, making gestures in some kind of ritual.

To help run the school, the sisters enlisted the help of Mary Snead's son, John Snead, of Lynville, Tennessee. Only, it took much arm-twisting by John's aunt, Caroline Martin, to get John to leave his wife and come to Christiansburg.

John Snead's arrival in town played out like the lyrics of some kind of nightmarish country song. First, he fell off a train near Roanoke in what could have either been an accident or a suicide

attempt. Next, the young man had to be rescued from a cistern at the school when he fell in and nearly drowned. Finally, inside the school in early 1906, John was found in a burning bed, soaked with kerosene and screaming. He died within hours from severe burns.

With his history, it looked as if John was suicidal or maybe he was just accident-prone. Certainly, that's what Virginia Wardlaw called that burning bed—an accident. Still, police suspected foul play; so did the attending physician and those good Christians of Christiansburg. Virginia Wardlaw, however, subsequently just went around town, soliciting affidavits. She wanted people to say that this truly was an accident. In the end, Virginia collected a reward: she was the beneficiary of an insurance policy taken on John Snead's life.

Oh, talk about a public relations nightmare! The questionable death of John Snead—and all that other odd activity—soon had the sisters' student population declining in droves. The Black Sisters racked up debt, which they either couldn't or wouldn't pay, and their school finally closed in 1908. All of the Black Sisters cleared out of Christiansburg by 1909, but that would not be the last time this courthouse town would hear of them.

In November 1909, Caroline Martin's daughter Ocey Martin Snead was found dead in the bathtub of a small dwelling in East Orange, New Jersey. Much like the earlier death of Ocey's cousin, John Snead, this young lady's death looked suspicious. Ocey was in her early twenties and was well remembered for her sweetness and beauty. She had married John's brother Fletcher, her first cousin. But Fletcher left her behind in New Jersey after the Black Sisters came to live with them. Then, left in care of the sisters, Ocey became emaciated and doped up on morphine. Next came her own death—in twelve inches of bathwater—with her head beneath the bathtub faucet.

Ocey might have killed herself; a suicide note was found. But, again, this might have been murder. Police simply thought it odd that it took more than a day for Virginia Wardlaw to contact them. Then when Virginia's answers seemed jumbled, they held her for more questioning.

The fate of the Black Sisters would unfold on the front pages of newspapers, and, with that, came the story of another odd life

The name Montgomery Hall on sidewalk steps is all that remains of the Montgomery Female Academy. The old Christiansburg Middle School—once a high school and now an alternative school—was built on the academy's building foundation. *Courtesy of the author.*

insurance policy—this one taken on Ocey's life, with the Black Sisters as beneficiaries.

Caroline Martin, Ocey's mother, pleaded guilty to murdering her daughter and was sent to prison; she later went insane and died at a mental health facility. Mary Snead, Ocey's aunt and the mother of John Snead, was tried as an accomplice and released to the custody of her son Albert. Lastly, Virginia Wardlaw, the unmarried sister, never went to trial: she simply starved herself to death, even before the trial began.

The old Mongomery Hall building lasted a few more decades; it became a boarding house. But, in the 1930s, it was torn down and a new structure was constructed on its foundation. This became Christiansburg High School, then Christiansburg Middle School and, finally, an alternative school. It is here, in the oldest section,

that custodians say they hear the distinctive sound of *clickety-clack* footsteps and feel they are being watched, especially late at night, when shadows are said to be seen around windows.

Inside the school, too, something may move.

While here, late one night at 3:00 a.m., school administrator Michael Marcenelle caught a glimpse of *something* in 2006—a vision that he could never explain: "I saw someone walk past the door…I yelled out," he said. "But, there was no one there."

What Lurks at the Lyric

Lyric Theatre, 135 College Avenue—Blacksburg, Montgomery County

What lurks at the Lyric Theatre of Blacksburg may be difficult to spotlight. People say they feel a heavy presence in this movie house. Some have heard footsteps along a back stairwell. "Everybody seems to know or think that the Lyric is haunted," said projectionist Robert Krickus. "But nobody really knows why."

Until 1989, the Kelsey family owned the Lyric Theatre. Joel Furr, who often stayed late in 1988 to help the Kelseys, would later tell of hearing a loud shriek at the aging cinema. The Kelseys would guess that this was the ghostly voice of a woman, allegedly heard to cry, "Let me out!"

Some say stray voices come from the odd pockets of the projection area. Possibly these are echoes of people in adjoining structures or maybe the voices of Virginia Tech students strolling outside the theater along College Avenue.

Or, perhaps, there is something else.

"What I heard was different people talking—at night, after everybody left," Robert Krickus said. "There's no cycle to it. It's very random as to when you hear things."

Folklore—but not necessarily fact—says a worker died during the construction of the theater, built with art deco and Spanish Colonial-revival architecture in the late 1920s. When opened on April 17, 1930, the Lyric held seating for nine hundred patrons

A circa 1934 photo shows the Lyric Theatre at the center of Blacksburg. At the time this photograph was made, the movie house showed *Upper World*, starring Ginger Rogers. *Courtesy of Susan Mattingly, the Lyric Theatre.*

and replaced earlier theaters using the same name, standing on Blacksburg's Main Street as early as 1909.

Renovated in the 1990s, with 477 seats, the Lyric builds a bridge between the sprawling campus of nearby Virginia Tech and downtown Blacksburg's historic district. It provides space for both classes and a cinema.

Even some shallow stories, still, have been enough to lure people to the Lyric for ghost tours. But possibly the main attraction stars all those mysterious nooks and crannies—the dark cubbyholes—of this theater. "And there are little things that don't seem to have any immediate purpose," said former manager Rance Edwards, "so that kind of adds to their creepiness."

HAUNTS OF THE HETH HOUSE

Radford University—Radford

With its hand-hewn logs and host of rambling additions, the Heth House would have naturally attracted a haunting tale no matter where it was located. But place it on the edge of a women's college in

the restrictive times of 1913, when more than two dozen students of what became Radford University had to keep fires blazing in open grates just to stay warm. And, now, just imagine the imaginations running wild.

As they did, the young ladies of Radford's State Normal and Industrial School for Women believed there were definitely haunts of the Heth House, a structure with white oak log portions dating to 1829. This house was once a great social center and a schoolhouse, overlooking the New River. It took its name from Captain Stockton Heth, a Confederate army veteran who had much of this structure enlarged sometime after 1866, adding a brick front.

Eventually, the Heth House grew into a Victorian structure, capped with a cupola and trimmed with a tower. The Heth farm, around the house, was sold in 1911 to form the college's main campus. Yet, for a while, the Heths held onto the Heth House.

The clan rented it briefly—to be used as a supplemental dormitory—when the new school opened in 1913. But they did not rent every room, and upstairs, it seemed, the owners only inspired mystery. The Heth family kept one room, in the tower of the Heth House, securely locked at the end of a long and winding stairway. Behind that locked door, the college girls believed, stood a haunt of great proportion.

The college's first president, John Preston McConnell, initially hired a couple, Mr. and Mrs. Avent, to live in the Heth House. President McConnell instructed Mrs. Avent to watch over the home as its matron. But Mrs. Avent would last only until November of that first school year. She fled, so unnerved by the talk of ghosts and the nuisance of the home's persistent prowlers. The college girls, meanwhile, would fend off not only Radford's ruffians but the city's many treasure seekers who wanted to dig holes in the basement kitchen, soundly convinced by a longstanding legend that a fortune lay hidden beneath the floor.

Near the Heth House, President McConnell had his name bestowed on the college library in 1932. Behind that library—in what is now a parking lot—the Heth House remained standing until 1958, consistently collecting lore year after year.

On October 29, 1937, Radford students staged a play called *Heth House* to celebrate all that could not be explained. Written

in the Play Writing Class of Dr. W.S. Long and set in 1913, *Heth House* depicted the lives of the earliest Radford students. "It deals with their experiences with ghosts that shriek and other mysterious happenings," the college newspaper reported.

M'Ledge Moffett played herself in this production. Officially the dean of women but mostly a den mother, Miss Moffett moved into the Heth House in 1913 following the resignation of Mrs. Avent. Miss Moffett also carried a gun, and she was known to fire shots at the Heth House's ongoing parade of prowlers. A male professor, Mr. Gilbert, was assigned to live in a bungalow behind the Heth House, but he had to develop a password to avoid any random shots by the pistol-packing dean: Mr. Gilbert approached Miss Moffett, always, while whistling the tune *I Know a Place Where the Four Leaf Clovers Grow.*

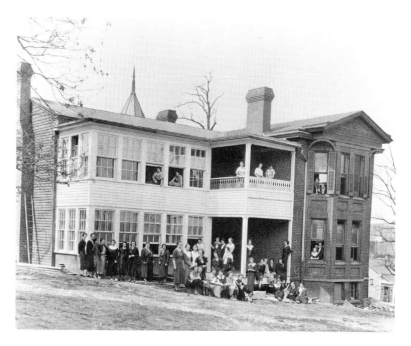

Heth House stood on the Radford University campus, behind the John Preston McConnell Library, until 1958. The early dormitory featured French and Italian-style architecture, gallery-style porches, towers and a cupola. *Courtesy of Radford University.*

After 1916, the Heth House reverted to the private residence of Miss Pickett Heth, who, for many years, resisted selling the property. Heth House finally became an official part of the college grounds in 1933, when it was sold, and was remodeled as the Home Management House for the college's home economics department. Briefly it became a dormitory again in 1949 but was left empty after 1951, its front porch rusting and its log interior infested with termites, until it faced its final destruction.

Ghost tales did not die with the Heth House. The school that grew into Radford University inspired a grab bag of haunts attached to other structures, including Tyler Hall, built in 1915 as one of the first buildings on campus. Allegedly, a female student hung herself in an elevator at Tyler Hall, and today her spirit causes some kind of audible commotion. No one quite knows, for sure, which elevator—or when or even really why—this incident happened. But some claim there is a certain negative feeling on the third floor of the building, and some students have reported hearing a mysterious cry.

WIN, LOSE OR DRAW

Wilderness Road Regional Museum—Newbern, Pulaski County

Upstairs, in the innermost reaches of the Wilderness Road Regional Museum, a sign hangs on a doorway, warning: "Private. Please do not enter." That doorway simply opens to the museum office. But in that office, a longtime story says, you might hear a ghost.

It's a legend leftover from nights when this was a gambling room in an old stagecoach stop. Sometime in the 1800s, a man lost his life by gunfire during a fight over a card game. Maybe he was winning; some say he was cheating; and some believe that man did not die with a bullet but by the plunge of a knife. Win, lose or draw, it's said that you can sometimes hear an unexplained racket in this room, particularly at night.

The Wilderness Road Regional Museum inhabits the Hance House, a ninety-nine-foot-long building with creaky, wooden floors standing at the center of Newbern. This village—once the

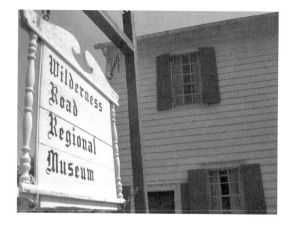

As legend goes, a man lost his life in a card game in an upstairs room, seen in the upper window, of the Hance House, now known as the Wilderness Road Regional Museum at Newbern. *Courtesy of the author.*

courthouse town of Pulaski County—grew up around the Hance House. The structure dates to as early as 1810, facing the Great Stage Road, or Wilderness Road to some. Besides having history as a stagecoach tavern, the Hance House has served as a general store, a post office and an inn. It takes its name from Adam Hance, the town's founder, and his son, Henry.

The museum's 120-square-foot office and adjoining attic boast more than twenty file cabinets, often known to have doors that seemingly open on their own. But, it would be bluffing to blame all these rambling rattles of the Hance House on an alleged ghost. Sara Zimmerman, a former office manager, finally figured out that large trucks rolling down the nearby highway could be causing some commotion.

Longtime museum volunteer Ed Moorer folded his hand, meanwhile, on one story that's been repeated in at least one book: Ed said an account of a boy seeing a ghostly man in the museum with blood dripping "down his side" was simply "a figment of my imagination." Ed actually created that entire episode to augment a few lines of a poem he had written about that legendary card game and the museum ghost.

HEAR ANGELS SINGING

Wabash Campground—Wabash, Giles County

They sang in unison, grand and joyous, rejoicing in spiritual fellowship. The old-fashioned church camp meeting was a way of life for many in the nineteenth century, and thousands ventured to quiet corners such as Wabash. Yet, at a particular Methodist meeting in the Wabash Campground, there appeared an extra angelic spark of excitement.

The tiny Wabash community took its name from a family that had been headed to the Wabash of Indiana but ended up in Giles County instead, settling along a creek between Staffordsville and Poplar Hill. This hamlet in Giles County, still isolated between steep-sided ridges, sits just above the Pulaski County border.

Here, as early as 1834, families would camp for two weeks in religious revivals. These Methodist meetings grew so popular that they attracted not only worshippers but also lured many outsiders— to see, be seen and even sell candy and melons to the crowds. The most dedicated Methodists, of course, only paid attention to the Scriptures and song.

About five thousand people attended one nineteenth century gathering, remembered by minister Dr. J.W. Perry as having "a tremendous surge of emotion." There, while singing *Jesus, Lover of My Soul*, several worshippers pointed upward and said they could hear angels singing. One woman said she could recognize her mother's voice. Others beamed, as they believed supernatural sounds joined their own.

"All the people who were on the right side of the shed were awestruck and excited," remembered Dr. P.L. Cobb, a Methodist minister in Chattanooga, Tennessee. "The look on their faces and their manner told the story. All of them, as far as I know, really believed they were listening to the singing of heavenly beings. They said, 'Angels.'"

At some point around 1896, unfortunately, the angels would sing no more. Fire consumed the campground shed at Wabash and destroyed not only the worship space but also many family shelters. The old-time campground meetings would be over.

MORE THAN DIRTY DANCING

Mountain Lake Resort Hotel—Mountain Lake, Giles County

People must have thought Christopher Gist was kidding when they went looking for what he called a lake or pond atop a mountain. This explorer had discovered what is now called Virginia's Mountain Lake on May 11, 1751, describing this pool as having "water fresh and clear, and a clean gravelly Shore." In a few years, however, settlers reached that same area and began questioning Gist's coordinates.

Was Christopher Gist lost? Did he make a mistake? Was there even a lake on this mountain at all? By the late 1700s, the earliest pioneers of what is now Giles County said this place looked only like a pond or like it had dried up. Yet then in a few more years, Mr. Gist's magical lake reappeared—a true natural wonder—at an elevation of 3,875 feet.

Mountain Lake has, in fact, been coming and going for centuries. Several springs feed the pool, and its waters rise with rainfall. Scientists say water periodically drains and refills through a hole in the lake's floor. And, every so often, an earthquake will shake the lake and affect water flow.

Hotels have graced its "clean gravelly Shore" since 1857. But early hotels were not always well received. One author, Edward Pollard, paid a visit to research his 1870 book *The Virginia Tourist*, in which he described "a bottomless lake suspended among the clouds." But, Mr. Pollard did not wax poetic about the lodge: "Poverty and filth surround the place. What is called a 'hotel' we found to be a single dreary house built like a barn."

In 1869, what had been called Salt Pond Hotel adopted the more eloquent name of Mountain Lake, a title bestowed by Cecelia Haupt, the wife of Brigadier General Herman Haupt. This Union officer and engineer redeveloped the resort. Coming from Philadelphia, Brigadier General Haupt said he had acquired the lake, hotel and surrounding land "by various turns of the wheel of fortune." He built a new hotel in the 1870s and made Mountain Lake a desirable destination. He also offered lake tours with a steamboat in the 1880s.

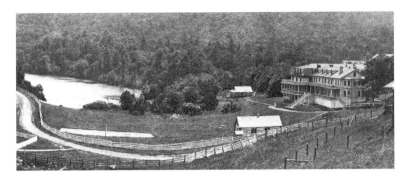

A circa 1921 view shows Mountain Lake, left, at full pond, and the wooden hotel built by Brigadier General Herman Haupt, at upper right. *Courtesy of Mountain Lake Resort Hotel.*

Brigadier General Haupt sold the property in 1891. Later, and for several years, the Porterfield family operated the resort. By the early 1930s, William Lewis Moody arrived and built the sandstone hotel that stands today, offering modern accommodations since 1936.

Mary Moody Northen, Mr. Moody's daughter, ultimately became the resort's owner. She kept a watchful eye on this property—her home away from home. A distinguished woman and quite classy, Mrs. Northen was known to make demands: she wanted her toast a perfect golden brown; her ice cream perfectly round; and her baked potatoes cut in half and smashed with a spoon. Yet she dearly loved Mountain Lake and, before she died, her will made sure that Mountain Lake would be protected in perpetuity. Stipulations also decreed that the resort stay old-fashioned and would exclude televisions in rooms of the main lodge.

By some accounts, Mrs. Northen has not left the building.

It is believed Mrs. Northen's spirit hovers in the hotel. A certain heavy presence may be found in her two-room suite, Room 100, a place that appears somewhat spooky. For years, this was Mrs. Northen's summer home, where little, if anything, has been altered since her death in 1986. "I think she's upset when we change things," said hotel chef Michael Porterfield, "which may be why her room has never been changed."

Just a month after Mrs. Northen died at age ninety-four, moviemakers moved onto the mountain and began shooting

something called *Dancing*. These film crews from Vestron Pictures spent three weeks capturing scenes of actors Jerry Orbach, Jennifer Grey and Patrick Swayze in the hotel dining room, at a rental unit called the Virginia Cottage and in Mountain Lake. Film crews painted yellowing leaves a green color, and chilly actors threw off their coats, pretending it was still summer. Yet, all the while, the directors did not have the nerve to call this movie what it really was—*Dirty Dancing*, the title used when it was released in 1987.

The surprising success of this low-budget, coming-of-age classic has since kept Mountain Lake alive with tourists, looking for the real-life Kellerman's Mountain House. But, the movie's raunchy plot—the seedy affairs, the thieving, the lying, the dance lessons in the gazebo—well, it is a wonder what Mrs. Northen might have thought of all this being filmed on her mountain.

Or maybe she did know. Perhaps she has been keeping an eye on this mountain all along.

Some staff members believe the ghost of Mrs. Northen watches the hotel through the eyes of her own portrait, hanging high above

A life-size portrait of Mary Moody Northen hangs above the fireplace in the library of the Mountain Lake Resort Hotel in Giles County. Mrs. Northen's father, William Lewis Moody, built the 1936 hotel. *Courtesy of Mountain Lake Resort Hotel.*

a fireplace in the library, just a few steps from the lobby. This is a carefully crafted photograph, blown up to life-size proportions, showing off all her wrinkles and rings. That picture is so large—and so life-like—that it simply looks alive. For years, staff members have shied away from staring too long at that picture, calling it intimidating. Mrs. Northen's eyes appear to follow your every movement. "It looks like she's watching you, keeping an eye on you, making sure you're not bothering her things," Michael Porterfield said. "And other times? She's staring off into space."

Mrs. Northen's spirit might also linger elsewhere, perhaps even in the cottage standing away from the hotel, at the far end of the lake. There, in about 1992, hotel employee Eric Wolf once stood locking up the gate to the resort house. He had just inspected everything, shut off the lights and closed up; no one else was around. But Eric got a creepy feeling. And, in looking up at the house, he noticed the ghostly appearance of an older woman's face in the lower corner of the upper right hand window.

Eric moved. The face did not. It just kept staring down from that window, he said, inside that locked house.

Going back to the house, on another day, Eric tried to replicate what he had seen. He adjusted furniture, lights—but nothing worked. He could not make that face appear. He came back time after time, though, still looking. He did not see the face until a year later. Looking up, while again closing that gate, there was that ghostly woman once more, he said, staring down from the window.

Soon after Eric's time as an employee in the early 1990s, Mountain Lake's waters began drying up. *Dirty Dancing* continued to attract fans, but the lake did not. Drought conditions dramatically shrunk the body of water, just as it likely did after its discovery by Christopher Gist.

Mountain Lake returned to full pool in 2003 and then sank again, going continually down until October 2008, when it dropped to virtually nothing—a huge crater—its lowest point in a century. It became a silty, murky mess measuring 225 square feet, drastically below its full pool of 55 acres. That sky-blue pool—the place where Johnny once held Baby above his head in *Dirty Dancing*—had been reduced to what looked like its own death.

That same autumn, some hotel guests discovered a pair of wingtip shoes caked in mud as well as coins, a class ring, a belt buckle and human bones. All belonged to thirty-seven-year-old Samuel Ira Felder, a hotel guest who fell from a rowboat in the moonlight of July 23, 1921. Mr. Felder had drowned, never once coming to the surface. "He was noticed to fling a cigarette into the water," the *Roanoke Times* reported, "and a few minutes later, his comrades saw him fall from the bow of the boat into the lake. He seemed to choke and struggle for an instant and then he was engulfed by the moonlit waves."

Teams searched for this man from Troy, New York, for about ten days. A deep-sea diver from Norfolk, Virginia, plunged the depths of Mountain Lake to no avail. Then, exasperated on September 30, 1921, hotel manager T.G. Porterfield wrote a note to Mr. Felder's brother, saying, "I regret very much to have to report that we have seen nothing whatever of the body. After the closing of the hotel, I personally made daily trips around the lake in a boat, but have seen no sign at all."

Whether Mr. Felder fell by accident or even had a heart attack may never be known. Still, the story of Mr. Felder's drowning—unknown to the modern hotel staff until his bones were found—might connect to the vision of a woman staying at a Mountain Lake cottage in the 1990s. On what hotel manager Buzz Scanland recalled as an eerie night, a guest reported a ghostly woman had shown up in her room, saying her son had drowned in the lake on a night similar to this one.

All became quiet again at Mountain Lake in the weeks following the discovery of Mr. Felder's body—all but the voice that echoed in the empty hotel lobby at 5:45 a.m.

Just before Christmas, while the resort was closed for the season, Chef Michael Porterfield approached the kitchen on a wintry morning in late 2008 and heard a mysterious voice, asking, "Who is that there?" The chef looked around the lobby, trying to find the source. Then he heard it again: "Who is that there?" It sounded more like a woman's voice than a man's, and it appeared to come from the direction of the library, the location of that portrait of Mary Moody Northen.

Logs lined the shore of a half-full Mountain Lake in 2006, about two years before the lake dried up in October 2008. The 1936 sandstone hotel, seen in the movie *Dirty Dancing*, stands in the background. *Courtesy of the author.*

The chef continued looking; he kept trying to find the source. But, in the end, he found no one else on the grounds.

To this day, movie buffs still turn out by the dozens for Dirty Dancing Weekend at Mountain Lake. The resort, in turn, remains romantic, long lauded as an "ideal retreat for peaceful relaxation"— even as Mountain Lake comes and goes, riding a tide all its own. The Silver Gem of the Alleghenies may still be the Coolest Place in the Sunny South. Yet with the face in the window, the stray voice in the lobby and the picture that seems to move, there appears to be much more than *Dirty Dancing* surrounding that natural wonder known as Mountain Lake.

ROANOKE REGION

New Castle—Salem—Fincastle—Bedford—Rocky Mount—
Woolwine—Meadows of Dan—Martinsville

SPIRIT OF THE SALESMAN

The Murder Hole—New Castle, Craig County

He was a salesman—possibly a very obnoxious salesman. Or, perhaps, this peddler of pots and pans just came calling on the wrong home during the nineteenth century in the mountains of Craig County. This salesman had approached a man so rich, yet so tight with money that he had kept all of his fortune hidden in a cave.

This rich man did invite the salesman to spend the night. Only, then, greed overcame him: the rich man stole all of that peddler's money.

Such details would not surface, however, until the rich man lay upon his deathbed with a bowel problem that caused internal bleeding. A visiting doctor had advised the rich man to take one of his fat sheep and make a broth. This, the doctor said, would help the rich man heal.

Soundly, though, the rich man refused, saying, "I cannot spare one of my sheep."

"But, you will," the doctor replied. "Or you will spare them all by morning."

Oh, how that rich man should have listened!

Not taking that medicine turned out to be fatal. And then, facing the final strains of life, the rich man's mind obviously became blurred

The craggy Murder Hole, situated on private land in Craig County, actually shares its name—and, yes, its legend—with another Murder Hole located in nearby Botetourt County. *Courtesy of the author.*

as he lay in bed, frothing with flashbacks. "Oh, lord!" he screamed. "I can see them! I can see them going in—and—they're—going—over—the—edge! I can see them going in!"

The rich man made a chilling confession in his dying breaths: he had killed that traveling salesman by tossing his buggy, his horse—tossing it all—into a seemingly endless cave in Craig County that forever became known as the Murder Hole.

Ringed by a scary cluster of ash and walnut trees, one opening to this limestone cave lies, partially, on the privately owned Sizer family farm, just a few miles southwest of New Castle. Oddly, though, it is not the area's only Murder Hole. And, even more confusing, a similar—if not the same—tale of a rich man and a peddler surrounds the other Murder Hole, located in nearby Botetourt County.

One farmer who owned part of the New Castle Murder Hole, James Frank Fulton Sizer (1895–1963), swore that he could once see buggy tracks lining the rocks at the rim of the Craig County

grotto. Mr. Sizer would also say that he could see lights coming out of the cave. Scientists, of course, might explain the illusion of lights being owed to phosphorous gas. But to Mr. Sizer, and others, that illumination provided proof that the tale of the Murder Hole was true and that the spirit of the salesman remains.

Mysterious Monterey

Roanoke College—Salem, Roanoke County

Monterey sits at the edge of Roanoke College, just barely on campus; but it resembles many of the college buildings, and the Greek-revival structure looks like it should be part of the campus. Quite naturally, many would have assumed as much. And, studying the history, they would have been right.

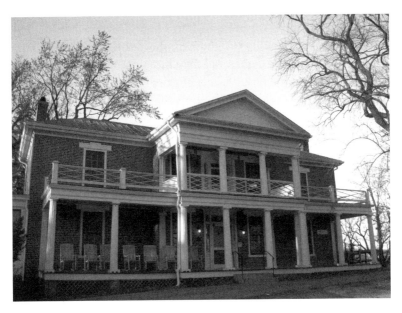

Monterey was built in 1853; it currently overlooks the Roanoke County Courthouse at Salem. The landmark became part of the Roanoke College campus in 2002. *Courtesy of the author.*

The Roanoke College campus sprawls across the center of Salem. Founded near Staunton, Virginia, in 1842, this school moved to Salem in 1847 and became Roanoke College in 1853. The school shares its name with Roanoke County and the nearby city of Roanoke, both named for a kind of shell once used as money.

Surely, a few college administrators must have lusted after Monterey. Built in 1853, the brick mansion overlooks the city of Salem, the location of the Roanoke County courthouse. Monterey once served as a hotel; it was a boarding house for college students in the 1890s; and, for a while, in the 1920s, part of the home was rented as a fraternity house.

In 2002, the college acquired Monterey and renovated it for use as a guesthouse.

Interpretations of how this home took the name Monterey have been inconclusive. Likewise, it's not quite clear who may now inhabit Monterey in a ghostly form. But, indeed, there have been sightings, and the most famous apparition even made its way into a local newspaper.

A member of the college's board of trustees stayed here on a Saturday night in 2005 as one of the first guests at Monterey—an experience that left her frightened, the woman told the *Roanoke Times*. "I was awakened after midnight by a tall woman at the foot of the bed, between the posts. Like a glowing, white mist. She seemed to be throwing something over me—a sheet?—and to scream at me as I screamed at her."

Folks who knew Katherine Albert Burke, the last owner of Monterey, might not guess that the easygoing, gracious Mrs. Burke would have reappeared as this glowing ghost, throwing anything. Still, Mrs. Burke did live here for most of seventy-five years with her father, Charles A. Albert, and as the wife of Richard Burke. Later, it's told, she made another appearance in December 2000, just a few weeks after her death at age eighty-five.

That year, Mrs. Burke's family decorated the home for their last Christmas at Monterey. And there, in the parlor, a friend of the family—the daughter of Mrs. Burke's son's girlfriend—caught a glimpse of what appeared to be Mrs. Burke.

Later, fueled by tales of sounds and sightings, mysterious Monterey became a favorite place to prowl for the students of

Tom Carter, an associate professor at Roanoke College. In the wee hours of the morning, these students ignore the loud gargles of the cranky radiator system and patrol dark hallways, using dowsing rods to determine any odd activity. Once, just as dowsing rods touched, a student's flashlight immediately cut off. Other students have reported seeing shadow figures. And, another time, some ghost hunters came into the home in 2007 and captured what appeared to be disembodied voices.

FIGGATS OF FINCASTLE

20 Main Street—Fincastle, Botetourt County

Captain J.H.H. Figgat came home from the Civil War, and, according to some, he was a lot better off than when he left. Somehow, someway—people say—he had made a pile of money.

Born on March 13, 1840, Captain Figgat grew up in Botetourt County and earned a degree in nearby Lexington, Virginia, at what became Washington and Lee University. He served in Company C of the 2nd Virginia Cavalry. Near the end of the war, he was wounded and came home to study law, eventually settling at Fincastle.

Established in 1772, Fincastle ranks among the oldest towns west of Virginia's Blue Ridge. Lovely and picturesque, it contains the courthouse of Botetourt County, a jurisdiction that once included virtually all of Virginia's Blue Ridge Highlands plus much or all of Kentucky, Illinois, Indiana, Ohio and West Virginia. This county—pronounced "Bot-a-tot"—took its name from Lord Botetourt, a popular royal governor. The town of Fincastle took its name from Lord Fincastle, the eldest son of Lord Dunmore, the last royal governor of Virginia.

Here, Captain Figgat built a brick home at 20 Main Street around 1880, with walls measuring eighteen inches thick. Nearby, he built a law office. He also served as the first president of the Bank of Fincastle in 1875.

But, in a turmoil of troubles or what some say must have been the fate of financial ruin, Captain Figgat found himself desperate in

1895, according to local lore, and allegedly jumped to his death at the home called Aspen Hill on Fincastle's Main Street.

That's the legend.

Historical accounts of that time, including an obituary in the *Fincastle Herald* on April 11, 1895, tell a different story: There is no mention of a suicide but instead the report of Captain Figgat suffering from a malignant disease of the left kidney. He had undergone an operation, the newspaper reported, as a last measure of "forlorn hope." A doctor had advised Captain Figgat that the operation "offered the only chance for life, and brave man that he was, he accepted the only hope, and that failing, he yielded up his life without murmur and without regret."

Then, according to the newspaper, Captain Figgat died at his house.

With a headline screaming, "CAPT. FIGGAT DEAD," it was obvious the passing of this man was major news; Captain Figgat had served in Virginia's House of Delegates and had been known, according to the newspaper, as "a man of decided principles." The newspaper heralded Captain Figgat as "a ripe scholar, gallant soldier of the Lost Cause, eminent lawyer and distinguished legislator."

Of course, with the young captain buried, the widowed Mrs. Figgat wanted to remain in her brick home on Fincastle's Main Street. But hard times seemingly fell on Eliza J. Figgat following her husband's death in 1895. Then—somehow, someway—her home went up for auction, and she had to buy it back in 1896 for $2,250.

At age seventy-three, Eliza Figgat died on December 19, 1914. And now, it's believed, her spirit inhabits the old Figgat house near the center of town.

The stately structure, sometimes mistaken for a small courthouse, was briefly used as an apartment building. After 1989, it returned to a single-family home.

Inside, owner Terry Tucker and her sister, Gaye, once could not find something. And they made a joke, saying, "Mrs. Figgat probably has it." Yet, then, imagine their alarm when all the lights in the house immediately flickered!

Another time, an exterminator visited the home and inspected the cellar, a gloomy dungeon that can be accessed through a trap door in an upstairs parlor or by a tiny outside entrance. This

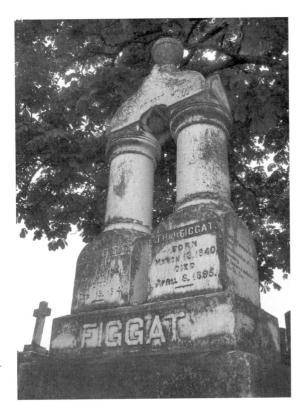

Captain J.H.H. Figgat (1840–1895) is buried with his wife, Eliza Figgat (1841–1914), at Fincastle, the courthouse town of Botetourt County. *Courtesy of the author.*

exterminator, a man in his thirties, returned upstairs to greet Terry with an ashen look on his face, a stern resolve and a tale, saying he could hear moaning in the cellar. "I don't know what's down there," the exterminator reported. "But I heard the weirdest noises, and I'm not going back."

Often, Terry Tucker would learn much about Mrs. Figgat from the late Gray Bolton, an elderly woman who had lived in the house during the mid- to late 1900s. Mrs. Bolton would frequently stop and offer warnings "to not clean the fireplace hearths, because Mrs. Figgat didn't like that," Terry said. "She talked about Mrs. Figgat like she was a person who had lived here with her."

For the record, Terry did clean her fireplace hearths. Still, she has sometimes had spooky notions of being watched at night, quite possibly by the ghost of Eliza Figgat.

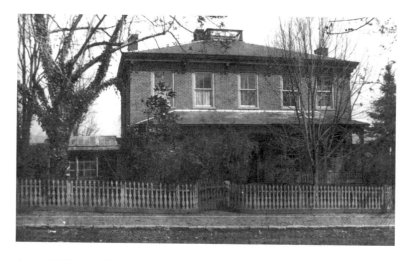

A circa 1896 view of the privately owned Figgat Home, 20 Main Street, in Fincastle shows the structure at about the time Eliza Figgat spent $2,250 to repurchase it. *Courtesy of Paul and Terry Tucker.*

"I never felt threatened," Terry said. "I actually think she was happy to have us here in this house. This is her home. They built it. And, a house like this has a personality."

Apparition at Avenel

Historic Avenel, 413 Avenel Avenue—Bedford

It was to be kept quiet. Each time if a man were to leave, if he was to go away for almost any reason, the heartache and the pain—all of it—was to be silenced; just keep it to yourself. Keep a smile on your face; say to no one what had happened; and, above all, let this be a happy home, with no grief whispered outside its walls.

Such were the ways of the Old South, where matriarchs marched to the tune of their men, whether those men remained home or not. If a husband were to go away, well, then it would be for a good reason—like to New Orleans, where William Burwell edited *Debow's Review* after 1865. A politician who had represented Bedford

County in the House of Delegates for the Virginia legislature, Mr. Burwell had commanded respect among Bedford's elite. But he would abandon his wife at the end of the Civil War, not returning home until the end of his life in 1888.

For his family, Mr. Burwell built the stately Avenel mansion, completing the home in about 1838. It was named for the ghostly white lady of Avenel, a castle depicted in Sir Walter Scott's novel *The Monastery*. Ironically, as it turns out, another lady in white has been reported at the Burwell home in Bedford.

This two-story, brick landmark stands prominent in this small city surrounded by Bedford County, which cleaves the Blue Ridge along its western border and fans eastward along the James River. Earlier called Liberty, the city, like the county, takes its name from English statesman John Russell, the fourth duke of Bedford.

General Robert E. Lee's wife visited Avenel in 1863, and General Lee arrived in 1867, stopping with his daughter, Mildred. By then, of course, Mr. Burwell had gone to New Orleans, leaving behind Mrs. Burwell, known affectionately as Ole Miss to Avenel's servants. Born in 1810, Frances Steptoe "Ole Miss" Burwell used grace and beauty and an unselfish character to oversee Avenel and her family.

But how could Avenel be *anything* other than a house of heartbreak?

At home at Avenel until her death in 1898, some say Ole Miss still exists. She is, at least, one of the leading candidates when it comes to guessing the identity of the ghostly lady in white seen famously floating in the front yard. The ghost is heard, it's said, by the swishing sound of moving fabric and detected by what one visitor called the stale smell of "little old lady perfume."

If not Ole Miss, then consider Letitia, the oldest Burwell daughter, known as Miss Lettie. Born in 1831, she lived here until her death in 1905. And it's thought that she—the daughter who never married— might really be the one still keeping an eye on Avenel.

But, wait: maybe it's Kate, one of Lettie's sisters and the second-oldest Burwell daughter. Catherine "Kate" Steptoe Burwell fell in love with Thomas Bowyer, a local doctor. And all was well, it seemed. But their marriage fell apart, and she returned home in grief to Avenel, where she died in 1899.

Just as likely, the apparition at Avenel could be Mary Frances, another daughter, who was known as Fan. She was a middle sister, and the one who fell in love with Captain James "Jimmie" Breckenridge at the onset of the Civil War. This couple got engaged but the war got in the way. They were not married until Jimmie got a furlough, and, even then, a blocked eastward train prohibited two of the groomsmen from making it to the nuptials.

Their big day finally arrived at Avenel on March 4, 1862. The bride, Fan, wore a veil plus a white silk and tulle dress "and what a beautiful bride she was," Lettie Burwell wrote in her diary. "The house was very brightly lighted, large fires everywhere, beautiful flowers in vases setting about which looked particularly lovely at this season when there are none blooming in the yard."

But Fan's happiness, like other ladies in the Burwell family, would come to a close. That summer, Fan made a special trip to see her new groom at a battlefield camp in Gordonsville, Virginia, and she came home with typhoid fever. Fan died at Avenel in August 1862.

Many years later, the family of Peggy Ballard Maupin moved into the home in 1906. There, Peggy remained until the late 1970s. For years, too, she would tell visitors a story that dated to the early 1900s. A gathering of women at Avenel turned to see a ghostly woman in white, wearing a hoop skirt and walking with her face in a shadow as she carried a parasol or small umbrella. Then, as Peggy would always say, this lady in white simply disappeared before everybody's eyes, behind an oak tree.

Peggy's husband, Harry Maupin, a local druggist, dismissed that story, until one day he had his own vision in the early 1960s: it was the lady in white, walking past a doorway at Avenel.

Just after Peggy's last day—on the day of her funeral, to be precise—something odd showed up outside Avenel. It was captured in a photograph; it appears to be a cloud of smoke, hovering above an all-terrain vehicle, on January 19, 2002. Perhaps, it's believed, Avenel has another ghost, because this cloud seems to be shaped exactly like the face of the dearly departed Peggy Ballard Maupin!

Today, that strange photograph hangs on the wall at Avenel, a home renovated in the early 1990s. Gracious and charming, the historic landmark is overseen by a foundation and often rented by

This white cloud formed in front of Bedford's Avenel mansion in 2002 on the day of former owner Peggy Ballard Maupin's funeral. It is believed to have taken the shape of the deceased woman's face. *Courtesy of Historic Avenel.*

blushing brides. Of course, on her big day, the bride becomes the lady in white. And while others may play the game of guessing the ghost, it's a given any bride at Avenel will be too excited to think about what other lady in white could be walking around.

WISPY WOMAN

Franklin Street—Rocky Mount, Franklin County

Delia Nichols dearly loved the dashing Mr. Pinkard. It was a love so strong that, in 1892, this pair chose to marry. But their families did not approve nor did they understand. And, finally, those families strictly forbid it.

Torn between love and loss and likely convinced she would never find happiness, Delia went outside with a rope and tried to hang herself. She took her sister with her but cautioned: until I'm lifeless, don't tell anyone.

A circa 1915 view of Railroad Street—now Franklin Street—in Rocky Mount shows how the street may have looked when Delia Nichols took her own life nearby in 1892. *Courtesy of Linda Stanley and the Franklin County Historical Society.*

The first time, the rope broke. On the second try, Delia died. Mr. Pinkard soon found out that news: Delia was gone. And, so distraught himself, he took a poison and joined his dearly departed lover in the hereafter.

Before long, this Romeo-and-Juliet-style story made news all over Rocky Mount, the hometown of Mr. Pinkard in Franklin County. Once named the Rock Mount for a mass of stone that later became known as Bald Knob, Rocky Mount lies at the eastern edge of the Crooked Road: Virginia's Heritage Music Trail.

Perhaps the tale of Delia's heartbreak would have made a good song for some bluegrass or old-time musician. But her spirit lives on anyway, some say, as a wispy woman seen on Franklin Street, a thoroughfare once called Railroad Street during Delia's day.

A woman wearing a white gown allegedly floats—without feet—near the corner of Franklin and West Church Streets. People have seen her gliding near the site of the Peoples National Bank building. It appears as if she is draped in a nightgown or possibly a prom dress. Or perhaps the ghost of this young woman simply wears a wedding dress—the one that she never got to wear.

Whiskey Man

Mountain Rose Inn—Woolwine, Patrick County

Joseph Howard "Joe" DeHart sported a big physique, dark hair, a mustache and a great sense of humor. Everyone called him Joe. He produced whiskey at his Mountain Rose Distillery No. 250. And, in 1901, he constructed a huge home near Rock Castle Creek in Patrick County.

Born in 1870, this whiskey man boasted a simple motto to his mail-order customers: "Honest Goods, Full Measure." And he posted many notices, advertising that "this whiskey is all 100-proof, and sold at $2.00, $2.25, $2.50 and $3.00 per gallon. You may, by chance, buy just as good whiskey as mine, but there is nothing purer, regardless of the price you pay."

Sometime after 1910, Joe moved his operation and his family from Woolwine to Philpott to be closer to a railroad station. Only six years later, Joe faced the dark days of Prohibition. With a new law enforced in 1916, he could no longer legally make his whiskey.

Even to the end, however, Joe poured humor in his advertisements, warning his customers on the subject of "preparedness," saying, "Good Whiskey will be Hard to Procure...It will be no bad idea to lay away a ten years' supply of corn whiskey strictly for medicinal purposes."

Or was that humor? It's been said that Joe would sell whiskey to his employees. But if he heard those employees got drunk, he would never sell them whiskey again!

Prohibition changed Joe's life. He returned to Woolwine to farm peaches and apples. He made vinegar, ran a roller mill and produced flour and meal. Along the way, and perhaps with sadness, he also had his distillery destroyed.

The DeHart home at Woolwine survived Joe's death in 1956, even though it was once nearly left to ruin. Finally, in the 1990s, the mansion bloomed again as the Mountain Rose, a bed and breakfast opened by Al and Suzie DuBree.

During renovations, Suzie DuBree began to hear the sound of walking on the creaking stairs, she said, and then what she called the ghost of Joe DeHart settling into a rocking chair in an upstairs

Mountain Rose Inn offers luxurious accommodations and tales of its legendary whiskey distillery at Woolwine in Patrick County, just off the Blue Ridge Parkway. The home was built in 1901. *Courtesy of the author.*

room. But such sounds, Suzie said, were not hard to swallow: It was simply as if the whiskey man was making himself at home again in the house that he built.

Suzie DuBree has now passed on and, it seems, so have the sounds of Joe DeHart's ghost. But his grand house—renamed the Mountain Rose Inn—still distills style and comfort, romantically nestled at the edge of the Blue Ridge.

ANGEL

Poor Farmers Farmhouse—Meadows of Dan, Patrick County

Buford Wood dutifully dug a ditch. It was for drainage on the gravel driveway of the Poor Farmers Farmhouse. Quite casually, Buford, the maintenance man, dumped out all the dirt. But there, in just

one tiny truckload, the caretaker turned up a tombstone: a marker bearing the name of Rozinah, the wife of Jonathan Conner. She was born in 1817 and died in 1900. And now her tiny grave marker—a gray stone—shone in the sun.

Coming home, Felecia Shelor found the tombstone odd, certainly strange. But, by then, the owner of the Poor Farmers Farmhouse had grown quite used to any and all odd happenings on her farm, centered by a nineteenth-century cabin that had been converted into a cozy farmhouse. Felecia's place once belonged to a family named Helms. She turned it into a vacation rental during the 1990s; then she closed the doors and simply decided to call it home.

All the while, Felecia took note of the unusual: Like when a little old lady asked her, "Does your house ever talk to you?" Or when she heard an overnight guest tell of a bed shaking. Or when Felecia walked into a highway department meeting at Meadows of Dan, and everyone just stopped and looked at her. Then one man said, "Your house is haunted."

And now comes Rozinah: why, oh, why was Rozinah's tombstone coming out of Felecia's driveway?

The Poor Farmers Farmhouse sits along a brook draining to the Dan River. It's only a few miles from the heart of Meadows of Dan, a Patrick County community lying at a crossroads of the Blue Ridge Parkway and the Crooked Road: Virginia's Heritage Music Trail. This place is perfectly picturesque with its large farm pond and rolling acres. And the late Buford—the maintenance man who could build anything—loved working here, even though he did keep seeing things.

Several times, Buford noticed a woman around the place—maybe a ghost, maybe an angel. But, one day, he was doing something in the yard, turned around and saw this lady—this blonde-haired lady—staring back at him from inside the house. And then? She just wasn't there anymore.

Another time, Felecia caught a similar vision. She looked upstairs, she said, and suddenly noticed a ghostly woman with long blonde hair, wearing a long, blue gown. And then? Well, that woman disappeared.

Nothing, Felecia figured, might ever explain how Rozinah's tombstone ended up in the driveway. And who knows the identity of

Dating to the mid-1800s, this privately owned home was once rented in the 1990s as the Poor Farmers Farmhouse at Meadows of Dan, near the Blue Ridge Parkway, in Patrick County. *Courtesy of the author.*

the ghostly woman. Still, Felecia holds all these haunts harmless and looks at any spiritual magic as actually the action of an angel. All, of course, would be fitting in this setting, one of the most tranquil pastures in all of Virginia's Blue Ridge Highlands.

HANGING JUDGE

Old Henry County Courthouse—Martinsville, Henry County

Caught speeding or reckless driving, you would not want to find yourself facing Judge Malcolm Hugh MacBryde Jr. at the old Henry County Courthouse in Martinsville. He was gruff. He seldom—and some say *never*—smiled. Judge MacBryde could hand down unmerciful sentences, perhaps making you feel like you had faced your last judgment. "He was so tough," remembered Paul Ross,

who once faced the judge in traffic court. "Everybody was afraid of Judge MacBryde."

Maybe some still are.

Colleagues called him "stern, but fair." The judge operated his court with the "utmost dignity," retired attorney Hannibal Joyce Sr. recalled in 1971 but said that dignity coincided with overwhelming shares of "seriousness and sternness." In fact, Judge MacBryde could be so stern that the citizens who came into his court just never forgot it: "He just gave very stiff sentences. He was not lenient at all," Paul Ross remembered. "He was a very tough judge. A very tough, hard judge."

Possibly this hanging judge might still be hanging around.

Judge MacBryde held rein for more than thirty years at the Henry County Courthouse, a landmark constructed in 1824 at the center of Martinsville. When the judge died in 1969 at age sixty-four, some say his demeanor did not. The older attorneys of Martinsville spoke

Judge Malcolm Hugh MacBryde Jr. served on the bench until 1969 at the old Henry County Courthouse in Martinsville. The landmark was built in 1824, with further additions in 1929 and 1940. *Courtesy of the author.*

of a restless spirit inside the courthouse. It could be a criminal; it could be a past attorney; or whatever presence seemed to remain just might belong to one stern-faced individual.

Perhaps Judge MacBryde really did haunt the courthouse.

Early one morning in the late 1990s, young attorney Debbie Hall came to the landmark for a Courthouse Days festival. Debbie had volunteered to set up historical displays at 4:00 a.m., and she arrived when the building was locked and secure and no one was inside.

Debbie got a sense she was not alone.

She heard footsteps upstairs, inside the locked courtroom. She walked all around downstairs, finding nothing unusual. Debbie called out, but no one replied. Then, she heard a creak in the floor and more footsteps. Again, she called out. There would be no answer. Once more, she tried.

Silence.

By then, Debbie began thinking about what all those older attorneys in Martinsville had told her—about the ghost of Judge MacBryde. And then, ever so quickly, she hurried out of the courthouse and waited outside for her friends to arrive, nearly an hour later with the rising sun.

To this day, Debbie Hall still has no answer: who made those phantom footsteps?

AFTERWORD

Fright Night

Reynolds Homestead—Critz, Patrick County

In darkness, I approached the Reynolds Plantation in Patrick County, alone at 11:00 p.m. on a Saturday in the heat of June. It was still hot at this hour, but I had a particularly odd feeling of heat on the back of my neck, like an electrical sensation, as I stood at the back door of the brick Reynolds Homestead. I felt short of breath.

Uneasy.

Yet this place was far from home, and I needed somewhere to rest for the night. So I fumbled with the key in the dark.

The Reynolds Homestead has been standing in Patrick County since the mid-1840s. Most famously, this was the birthplace of R.J. Reynolds (1850–1918), a tobacco business mastermind and manufacturer of Camel cigarettes. In short, I knew some general Reynolds family history. I knew, too, that people had not only been born but had also died inside this house. Such stories would serve as the focus of my talk at the visitor's center on that following Sunday.

I also once visited this home, on a sunny day in 2005. But I had never been to the upstairs apartment—not until this dark night, all alone in 2009.

Bypassing the museum exhibits of the downstairs, I climbed the steps. And every detail made me sensitive, especially when I passed through a library room. Understandably, I was startled to see a mouse run across the floor. But I was even more alarmed by the sense that something else was in the bedroom, especially after passing through a cold spot.

I hurried away, running through the library and locked myself in the semimodern kitchen. There, I felt relatively safe, but only as much as somebody who was about six years old—not forty. There was something, I was convinced, something beyond that door— some *presence*.

I called my wife, telling her I just could not stay here. I did not hear, smell or see anything. But, oh, there was something here, I babbled, and I felt sure that it really didn't want me here with it.

So I left. I drove a half-hour into nearby Martinsville. Briefly, I contemplated sleeping in my car. Then I searched for a hotel. But, at nearly 1 a.m., most places appeared closed. And the one place I did stop demanded such a high amount of money, for what appeared to be substandard accommodations, I finally retreated to the Reynolds Homestead to face my fears.

I ran through the front yard, bypassing the gnarly, twisted limbs of the Catalpa tree that looked like it wanted to grab something or somebody. Then, like a small child afraid of his grandmother's ghost, I rushed upstairs to that semimodern kitchen and locked the door. I felt safe but still scared, even with all the lights on and the radio blasting, as I fell asleep on the couch at 2:00 a.m.

The next morning, the sun shined. And, surprisingly, I had not a single fear—except I really did not have the guts to go downstairs.

Then came a phone call, and I learned my fears might not have been so irrational: "We do have guests tell us all that they feel something," said Beth Almond Ford, a historical services assistant at the Reynolds Homestead. "I have always felt a presence in the house, each and every time I go into it. It's never been frightening nor the least bit scary, but it is as if there are spirits present."

Once, Beth said, a woman from South America felt a presence in the home and even stated that she saw several male apparitions over the course of two nights.

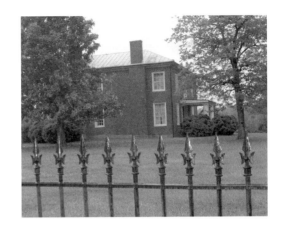

A wrought-iron fence surrounds the Reynolds family cemetery, lying just a few yards from the circa 1840s brick home of the Reynolds Homestead at Critz in Patrick County. *Courtesy of the author.*

Another time, an artist-in-residence staying here in the 1990s felt especially troubled. "As she was sleeping the first night, she woke up to find an elderly 'man' grabbing onto her arm and refusing to let go," Beth said. "The next day, she walked around the house, the graveyards and the grounds."

That artist told the spirits—whoever they were—that all must coexist peacefully, and she really needed to get her sleep.

Perhaps my fear came from what I already knew—what had happened to all the children. In 1862, an inoculation-gone-wrong turned into a tragedy, killing three children younger than age seven in this household.

I also kept thinking about little Nancy Ruth Reynolds, a six-year-old girl who died here fifty years later.

In later months, I would meet Sharon Kroeller, a longtime Reynolds Homestead volunteer who had never spent the night and had shared nothing initially with me—only, too, that she had sensed *something.* "I could feel the presence of people there," Sharon said. "When I feel a presence, I have a very heavy feeling on my chest. I have heart palpitations. And there's almost a feeling of adrenaline that runs through me."

It was the same thing that I sensed.

Downstairs, in the living room, a place where I did not dare go that night, Sharon felt a particular heavy presence next to the fireplace—a sense that there had been a catastrophe. On the second floor, in

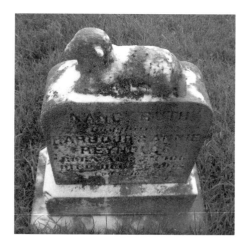

A marble lamb rests on the gravestone of Nancy Ruth Reynolds (1906–1912), who lost her life at the Reynolds Homestead and is buried near the brick home. *Courtesy of the author.*

the library, where I had turned so lifeless, she felt more: "I smelled smoke—not pipe smoke, not cigar smoke—smoke. I felt heaviness throughout the upstairs. But the room that I got focused on, for whatever reason, was that room with the smell—the smoke smell."

It was that room—the library—that had me frozen cold like a child, snagged by every detail of every book. It was that room that Sharon, also, had sensed many men rushing around in frenzy. "And I sensed men, as opposed to women or children," Sharon said. "I just felt the heaviness up there, that there was a presence—and there was hustle and bustle in there, that there was a lot going on in that room."

I took a deep breath.

In the daylight after my fright night at the Reynolds Homestead, I followed the precedent of that guest artist who had stayed in the upstairs apartment: I went outside and walked the graveyard. Specifically, I focused on little Nancy Ruth Reynolds. It was her story that I had already known—and one that had both touched and troubled me.

Nancy was a daughter of Hardin Harbour Reynolds, one of R.J.'s little brothers. In 1912, she reached for her Christmas stocking on the mantel and died that December after deeply inhaling flames.

Today, a marble lamb sits atop Nancy's gravestone as she sleeps forever in the hills of Patrick County. Before leaving, I thanked that little girl for letting me sleep a night in her house, and I told her I was sorry that she had died so young.

SELECT BIBLIOGRAPHY

Books

Aird, Brandon and Diane Silver, ed. *Time It Was: Snapshots of Emory & Henry College.* Emory, VA: self-published, 2004.

Arnold, Scott David. *A Guidebook to Virginia's Historical Markers.* 3rd ed. Charlottesville: University of Virginia Press, 2007.

Barbery, Willard Sanders. *Story of the Life of Robert Sayers Sheffey.* N.p.: n.d.

Bedford County Heritage Committee. *Bedford County, Virginia Heritage: 1754–2003.* Bedford, VA: self-published, 2003.

Botetourt County History Before 1900 Through County Newspapers. Fincastle, VA: Botetourt County American Bicentennial Commission, 1976.

Bucklen, Mary Kegley and Larrie L. Bucklen. *County Courthouses of Virginia Old and New.* Charleston, WV: Pictorial Histories, 1988.

Cohen, Stan. *Historic Springs of the Virginias: A Pictorial History.* Charleston, WV: Pictorial Histories, 1981.

Curtis, Claude D. *Three Quarters of A Century at Martha Washington College.* Bristol, TN: King Printing, 1928.

Davids, Richard C. *The Man Who Moved a Mountain.* Philadelphia: Fortress Press, 1970.

Emmert, Donnamarie. *Haunted Historic Abingdon, Vol. 1.* Abingdon, VA: Self-published, 2004.

Franklin County Retail Merchants Association, Inc. *Rocky Mount, Virginia: Railroadin' Since 1880*. Rocky Mount, VA: Franklin County Historical Publications, 2000.

Givens, Clyde and Nathalie. *Recipes, Folklore, Superstitions, Home Remedies, and General Pleasantries*. New Castle, VA: Craig County Historical Society, 2005.

Givens, Lula Porterfield. *Christiansburg-Montgomery County, Virginia: In the Heart of the Alleghenies*. Pulaski, VA Edmonds Printing, 1981.

————. *Highlights In the Early History of Montgomery County, Virginia*. Pulaski, VA: B.D. Smith and Bros., 1975.

Goode, June B. *Our War: An Account of the Civil War in Bedford, Virginia*. Lynchburg, VA: Warwick House, 2003.

Hagemann, James A. *The Heritage of Virginia*. Norfolk, VA: Donning, 1986.

Kanode, Roy Wyete. *Christiansburg, Virginia: Small Town America At Its Finest*. Kingsport, TN: Inove Graphics, 2005.

Kegley, F.B. *Kegley's Virginia Frontier*. Roanoke, VA: Southwest Virginia Historical Society, 1938.

Kegley, Mary B. *I Like Molly Tynes Whether She Rode Or Not: And Twenty-Five Other Tall Tales and Cherished Myths*. Wytheville, VA: Kegley Books, 2003.

Kent, William. *A History of Saltville*. Saltville, VA: Self-published, 1955.

Leslie, Louise. *Tazewell County*. Johnson City, TN: Overmountain Press, 1995.

Loth, Calder, ed. *The Virginia Landmarks Register*. Charlottesville: University Press of Virginia, 1999.

McKnight, Brian D. *Contested Borderland: The Civil War in Appalachian Kentucky and Virginia*. Lexington: University Press of Kentucky, 2006.

Niederer, Frances J. *The Town of Fincastle, Virginia*. Charlottesville: University Press of Virginia, 1965.

Patrick County Historical Society. *History of Patrick County, Virginia*. Stuart, VA: Patrick County Historical Society, 1999.

Phillips, V.N. *Bristol Tennessee/Virginia: A History—1852–1900*. Johnson City, TN: Overmountain Press, 1992.

————. (Bud). *Pioneers In Paradise*. Johnson City, TN: Overmountain Press, 2002.

Pollard, Edward Alfred. *The Virginia Tourist*. Philadelphia: J.P. Lippincott, 1870.

Price, Charles Edwin. *The Mystery of Ghostly Vera and Other Haunting Tales of Southwest Virginia*. Johnson City, TN: Overmountain Press, 1993.

Radford University Foundation Press. *Radford University: Investing in Lifetimes*. Richmond, VA: Carter Printing, 2006.

Reynolds, A.D. *Recollections of Major A.D. Reynolds 1847-1925*. Winston-Salem, NC: Reynolda House, 1978.

Roberts, Virginia Finnegan. *Mountain Lake Remembered*. Austin, TX: Nortex Press, 1994.

Roberts, W. Keith, et. al. *The House by the Wilderness Road*. Dublin, VA: Pulaski Printing, 1998.

Slaughter, Frank L. *How He Made Millions*. Bluff City, TN: B&I Printing, 2009.

Smith, Barbara. *Haunted Theaters*. Edmonton, AB: Ghost House Books, 2002.

Stanley, Linda. *Ghosts & More: Spirits In Rocky Mount, Virginia*. Rocky Mount, VA: Franklin County Historical Society, 2008.

Stevenson, George J. *Increase In Excellence: A History of Emory and Henry College*. New York: Meredith, 1963.

Summers, Lewis Preston. *History of Southwest Virginia 1746–1786, Washington County 1777–1870*. Johnson City, TN: Overmountain Press, 1989.

Tilley, Nannie M. *Reynolds Homestead 1814–1970*. Richmond, VA: Robert Kline, n.d.

Trowbridge, J.T. *Cudjo's Cave*. Boston: J.E. Tilton, 1864.

Wills, Brian Steel. *No Ordinary College: A History of the University of Virginia's College at Wise*. Charlottesville: University of Virginia Press, 2004.

Wilson, Joe. *A Guide to the Crooked Road: Virginia's Heritage Music Trail*. Winston-Salem, NC: John F. Blair, 2006.

Wood, Dr. Amos D. *Floyd County: A History of Its People and Places*. Blacksburg, VA: Southern Printing, 1981.

Woodruff, Patricia Robin, ed. *Strange Tales of Floyd County, VA.* Emporium, PA: Gryphon Software, 2007.

Writers Program of the Works Progress Administration. *Virginia: A Guide to the Old Dominion.* New York: Oxford University Press, 1940.

ARTICLES

Adams, Mason. "Rocky Mount Tour Tries to Glimpse at least One Ghost." *Roanoke Times*, October 14, 2005.

Alvis-Banks, Donna. "Ghostly Tale of Duck Pond Apparition Haunts Couple." *Roanoke Times*, October 31, 2003.

Angle, L.C. Jr. "War Comes to the Highlands." *Historical Society of Washington County, Virginia, Bulletin* 2, no. 25 (1988).

Brockman, Laura. "Ghosts of Past Still Frighten New River Valley." *Collegiate Times*, October 31, 2006.

Campbell, Meade. "Odd Fellows Inspired Martha Washington College." *Washington County News*, July 25, 1968.

Carroll County Historical Society. "Woodrow Worrell House." *Carroll County Chronicles: The Journal of the Carroll County Historical Society* 27 (Winter 2006).

Carter, Emily Paine. "Is 'Monterey' a Haunted Mansion?" *Roanoke Times*, October 26, 2007.

———. "Monterey's History Sheds Light on Reports." *Roanoke Times*, November 2, 2007.

Crooke, Jeff. "RUmors, Myths and Prophecies." *RU: The Magazine of Radford University* (December 2001).

Dunn, J.A.C. "Book Lover Shuns Modern Life." *Southwest Times*, January 13, 1974.

Firebaugh, Anita J. "Botetourt Haunts and Tales." *Fincastle Herald*, October 29, 2008.

Grapurchat. "'Heth House' and 'No Road Back' to be Given Friday." October 26, 1937.

———. "Heth House Removed from Campus; History of Building Is Reviewed." January 31, 1958.

Gregory, Ann. "Area Tourism Gets Big Boost with this Week's Opening of Greystone Bed and Breakfast." *Clinch Valley Times*, November 18, 1993.

Grundon, Anne. "Trainstation Transaction: Foundation Closes Landmark Deal." *Bristol Herald Courier*, September 2, 1999.

Hagy, James William. "Courthouses of Washington County." *Virginia Cavalcade* (Autumn 1975).

Harper, Judy. "Local Lore Full of Ghostly Tales." *Fincastle Herald*, October 26, 1994.

Howell, Isak. "Roanoke College Now the Proud Owner of Historic Salem Home." *Roanoke Times*, October 31, 2002.

Jeffries, Mel. "Blacksburg's New Theater to Be Open Thursday; Formal Dedication to Be Held One Week Later." *Roanoke Times*, April 16, 1930.

Key, Lindsay. "The Ghost Hunters." *Roanoke Times*, October 29, 2007.

Kincaid, Chuck. "The White Lady of Avenel." *Roanoker* (October 1993).

King, Heather. "Hill City Haunts." *Lynchburg Living* (September–October 2008).

Lindsey, Nancy. "Mountain Rose Blooms Again as B&B." *Enterprise*, July 29, 1992.

Roanoke Times. "S.L. Felder, Troy, N.Y., Falls Overboard at Mt. Lake; Drowns." July 26, 1921.

Smith, Marion O. "The Cumberland Gap Cave System: A History Emphasizing Early Visitation." *Journal of Spelean History* 16, no. 4 (October–December 1982).

Smith, Rain. "Spirits Said To Linger Throughout Historic Abingdon." *Washington County News*, October 30, 2002.

Snider, Betty Hayden. "State Adds Salem House to Landmark Registry: It's Still Just Home to Her." *Roanoke Times*, April 25, 1998.

Southwest Virginia Enterprise. "Dry Gulch Junction Employee Killed In Accident." July 17, 1979.

———. "Major Graham Mansion Joins VA Landmark List." December 18, 1984.

Spiker, Linda. "Ghostly Shadows in Old Mansion." *Southwest Virginia Enterprise,* January 4, 1997.

Tennis, Joe. "Sweet Virginia Breezes." *Blue Ridge Country* (May–June 1997).

Willis, Bob. "Name May be a Misnomer, but the Murder Hole Is Still a Fascinating Grotto with Four Neighbors." *Fincastle Herald*, October 21, 1998.

Witt, John. "Rich Wythe Recluse Lives With Million Books." *Roanoke Times,* March 5, 1978.

REPORTS, BROCHURES AND PAPERS

Adams, James Taylor. "Appalachian Tales: The Haunted Swimming Hole." File at Blue Ridge Institute, Ferrum, VA.

———. "The Haunted Swimming Hole." File at Blue Ridge Institute, Ferrum, VA.

Brewer, Mary Lin. "Major Graham Mansion: History." Max Meadows, VA, 2010.

Coleman, Ron. "Breaks Interstate Park." Breaks, VA: Breaks Interstate Park Commission, 1989.

Everett, Julia. "The Haunting of Christiansburg Middle School and Mountain Lake Hotel," November 27, 1995. File at Appalachian Regional Studies Center, Radford University, Radford, VA.

Hill, Jenny L. "A Local Legend: Three Sisters in Black," November 1999. File at Appalachian Regional Studies Center, Radford University, Radford, VA.

"Mendota Trail Development & Management Plan." December 2000. Washington County, VA.

Smith, Daneille. "The Craig County Murder Hole: The Legend of Niday and the Peddler," December 5, 2007. File at Appalachian Regional Studies Center, Radford University, Radford, VA.

Trear, Kelley. "The Legend of Willie Jack: Oral Traditions of Camp Alta Mons," December 1, 1998. File at Appalachian Regional Studies Center, Radford University, Radford, VA.

Williams, Daisy N. "Self-Tour Map of Historic Newbern."
Newbern, VA.: Newbern Promotional Bureau, 1994.
Wills, J. Travis. "Three Evil Sisters in Black," November 30,
1993. File at Appalachian Regional Studies Center, Radford
University, Radford, VA.

ONLINE REFERENCES

Furr, Joel. "The Ghosts of the Lyric." www.furrs.org/writing/
ghosts.htm (accessed June 21, 2009).
Mountain Rose Inn. "The Inn's History." www.mountainrose-inn.
com/history.htm (accessed February 2, 2010).
Shelor, Felecia. "Buford Wood, Mountain Man—Goodbye, My
Friend." poorfarmersmarket.biz/buford.htm (accessed June 12,
2010).

ABOUT THE AUTHOR

Joe Tennis, a native of Virginia Beach, Virginia, is a longtime collector of history and folklore of Virginia's Blue Ridge Highlands. A Radford University graduate, Joe has contributed articles and photos to *Blue Ridge Country*, *Bristol Herald Courier*, the *Roanoke Times*, the *Virginian-Pilot*, *Kingsport Times-News* and *Appalachian Voice*. He has also written for *Virginia Living*. The author's other books include *Beach to Bluegrass*, *Southwest Virginia Crossroads*, *Sullivan County Tennessee* and *The Marble and Other Ghost Tales of Tennessee and Virginia*.

Author Joe Tennis. *Photograph by Abigail Tennis.*

Please visit us at
www.historypress.net